Subdued Hues

Mood and Scene in Southern Landscape Painting, 1865-1925

Estill Curtis Pennington
Morris Curator of Southern Painting

Morris Museum of Art
1999

For Edie and Barry Bingham, with love

ISBN 1-890021-09-1

Published in conjunction with an exhibition held November 18, 1999 through January 16, 2000, at the Morris Museum of Art, Augusta, Georgia.

Cover Detail: *Wooded Landscape*, c. 1900, by Harvey Joiner (1852-1932).
Oil on canvas, 28 x 40 inches. Morris Museum of Art.

We are surrounded by things which we have not made and which have a life and structure different from our own: trees, flowers, grasses, rivers, hills, clouds. For centuries they have inspired us with curiosity and awe. They have been objects of delight. We have recreated them in our imaginations to reflect our moods. And we have come to think of them as contributing to an idea which we have called nature. Landscape painting marks the stages in our conception of nature.

Lord Kenneth Clark of Saltwood [1]

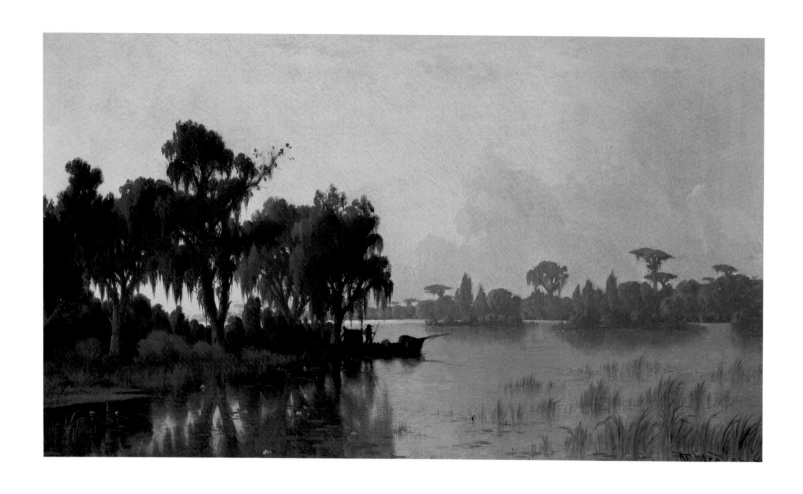

Joseph Rusling Meeker
 1827-1889

Solitary Pirogue by the Bayou
 1886
 Oil on canvas
 17¾ x 30 inches
 Morris Museum of Art, Augusta, Georgia
 1993.004

FOREWORD

There is something endlessly fascinating about the Southern landscape. Whether the setting is the bayou country of Louisiana, the hills of Tennessee, or the red clay and tall pines of Georgia, the land is important in the culture and history of the South. Artists have long been attracted to the Southern landscape, as evident in the wide range of landscape paintings in the Morris Museum's permanent collection of Southern art.

In this exhibition and catalogue, Estill Curtis Pennington, Morris Curator of Southern Painting, brings together landscapes created between 1865 and 1925, from the Morris Museum's collection and from other museums and private collections. As a native of the blue-grass region of Kentucky who now spends much of his time in Amsterdam, he brings both homegrown appreciation and the perspective of distance to his topic, exploring the image of the Southern landscape as an exotic other, envisioned as a "moss-hung and moon-lit world that time forgot."

We are grateful to the following institutions and individuals, who have so graciously agreed to lend paintings for this exhibition: the Albright-Knox Art Gallery, Buffalo, New York; the Brooklyn Museum; Cheekwood, Tennessee Botanical Gardens and Museum of Art, Nashville; Isabel McHenry Clay; The Columbus Museum, Columbus, Georgia; Greenville County Museum of Art, Greenville, South Carolina; The Merrill Gross Family Collection; Samuel P. Harn Museum of Art, Gainesville, Florida; Hunter Museum of American Art, Chattanooga, Tennessee; Mint Museum of Art, Charlotte, North Carolina; Montgomery Museum of Fine Arts, Montgomery, Alabama; New Orleans Museum of Art; The Ogden Collection, New Orleans; The Speed Art Museum, Louisville, Kentucky; and the Sam and Robbie Vickers Florida Collection. Thanks also go to the Morris Museum staff, in particular Catherine Wahl, Kelly Woolbright and Cary Wilkins, for support of the exhibition and publication.

William S. Morris III
Chairman of the Board of Trustees,
Morris Museum of Art

James Everett Stuart
1852-1941

Born, Dover, Maine; studied with Sacramento artist David Woods, and with Virgil Williams and R.D. Yelland at the San Francisco School of Design; active in the Pacific Northwest from his studio base in Portland, Oregon, 1881-1886, in the Yellowstone Region, and in New York, 1886-1890; active in Chicago, 1892-1912, and San Francisco, 1912-1941; died, San Francisco.

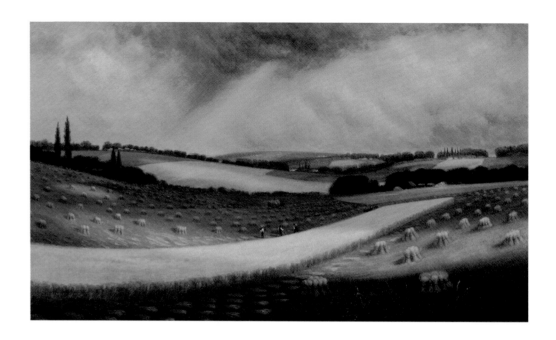

Kentucky Harvest
1909
Oil on canvas
24 x 42 inches
Merrill Gross Family Collection

Stuart's curious itinerancy, which took him most often to Alaska and the far northwest, must have included a stop in Kentucky where this sweeping pastoral scene is said to have been painted in the Louisville area.

Subdued Hues

Long before air conditioning lured Southerners in from the front porch, or shopping malls beckoned the citizens of small Southern towns to leave their main streets for constantly temperate interior walks, there was a Southern landscape. Of course, there is not one Southern landscape any more than there is one South.

There is the Appalachian mountain spine that routes the hiker down from the valleys of Virginia into the foothills of Alabama. There are the bayous and coastal wetlands that swamp the shores of Georgia, Florida, and Louisiana. There are the gently rolling pastures and green fields of Kentucky, and Tennessee, the black belt of Alabama and the Delta of Mississippi. All of these have been represented by painters in the South, some native, some itinerant, and none likely possessed with socio-cultural agendas dripping idly from their brushes *en plein air.*

These days it is as hard to speak of the South, and Southern culture, as ever, yet certain ideas about the South endure. And why not? Images of the South provide the exotic other, existing outside prevailing American notions of self, of entity, of *patrios,* of place. The South has not had the safety valve of Western expansion, of pushing ever onward. It is a place where the same turf has been worked and worked, rather like wilderness preserve in Mississippi neither relinquished nor enjoyed.

The landscape paintings that emerge from this setting are not romantic evocations of progress's inevitable triumph over nature. Quite the reverse. In the swamp paintings of the deep South we see a mysterious realm which will forever defy cultivation, one which stinks and rots and entices by its very remoteness. In the Appalachian and lowland paintings of the upper South we see wind stirring gently through the diaphanous needles of scrub pine, dwelling on a place which is and is to be.

This exhibition brings together a group of paintings that augment holdings of the Morris Museum of Art. They are drawn from three very distinct regions of the South, itself a "region" only in the geo-political sense. The concerns of the exhibition are those of cultural history illustrated by subtle shifts in style toward a realism and naturalism in art influenced by the French Barbizon and Dutch Hague Schools, and colored by tonalist color harmonics. It is also an exhibition which seeks to explore how landscape painting in this region differs from those works created in the same period by far more noted artists seemingly expressing the national mood.

Considerations of landscape painting in the South in the period under review must take into account certain formal art historical criteria, although estimations of form, color, line and design will not really complete the picture. The nuance of landscape art is as site-responsive as portraiture is sitter-reflexive. Viewing landscape painting can provoke an ironic curiosity, an awareness that what is seen is at once familiar and provocative, far more precise than that which might be experienced when gazing at an unkempt field or an encroaching forest.

Kenneth Clark's feeling that landscape painting "marks the stages in

our conception of nature" is especially relevant to this study. As a reflection of the national mood, and the deviations therefrom, landscape art becomes a cultural marker. Clark has observed that "in the early nineteenth century, when more orthodox and systematic beliefs were declining, faith in nature became a form of religion."[2] By extension, one might propose that within this religion there were conformists and non-conformists.

Study of landscape painting in the South requires a clear understanding of the symbolic role nature and the landscape played in the nineteenth century American imagination. Inherent in this tradition are two very persistent ideas: a belief in the God-given right of American pioneers to the land they settled, and rather pervasive emotive expressions, springing from the Romantic movement, that nature was the benign canopy beneath which our most precious moments occurred. According to Joshua Taylor, most American landscape painters emerged from a "long tradition that found nature, especially American nature, holy."[3]

Taylor felt that these artists' "perception was so linked to a sense of mystery in nature that to speak of it as to any degree objective would be to falsify its character." Filled with awe for the natural scene, these were not artists who could "look dispassionately at nature...(for) landscape had a special place in the psyche of America that was not easily displaced by artistic modes."[4]

In the Romantic landscape painting tradition personified by the luminist movement of the mid-nineteenth century, scale and vast panoramic vistas provided a virtually eternal view. In this view the depth of perspective carried the implicit narrative that upon this continent we could move ever farther, ever deeper, into the awesome landscape before us. The perspectival theme speaks to the highly colored optimism of transcendentalism and land grant opportunism.

Writing for the pivotal publication on luminism, Earl Powell could identify a true American sublime in landscape art, one in which the "sublime was expanded to encompass also the feeling of spiritual calm man derived from the contemplation of boundless panoramas and light-filled landscapes that emphasized the illusion of space, infinity, and quiet."[5]

But by the period under consideration, two totally unrelated happenings had engendered a startling shift in American landscape art. The Civil War challenged notions of a single American identity, if not a unified American state, bringing an end to the Whigish era of American optimism in bloody carnage. Even as that war was ending, a new artistic current was flowing into the country from Western Europe. A spirit of realism and naturalism, devoid of dramatic vistas, but occupied by pastoral concerns, was emanating from the French forests of Barbizon and from the Dutch sand dunes near den Hague.

If we can permit ourselves to indulge in the same reverential awe for landscape apparent in the mentality of that time, we might envision that three American landscapes emerged from that startling break in time: the landscape of mood, the ongoing landscape of manifest destiny, and the landscape of the exotic other. The landscape of mood has been studied as academic tonalism, more gravely concerned with painterly effect than narrative implication, landscape derived from the emergence of northeastern academies, especially in Boston and New York which translated avant-garde European styles into tonalism and impressionism. The landscape of manifest destiny perpetuated, in gigantic canvases by Thomas Moran and Albert Bierstadt, among others, notions of a vast extended terrain for colonial development.

The landscape of the South provided an altogether different escape for the popular imagination, one into which the traveler entered a land which time forgot, a landscape whose self-identity perpetuated agrarianism in the face of industrialization, and whose limited economic development insured the perseverance of the most reactionary setting in the nation-

state. There, painters spurred on by popular culture and nascent tourism created landscape views of swamps, bayous, grasslands and mountain valleys, terrains that were deemed altogether unsuitable for development.

And this was the landscape of the exotic other, which, by the late nineteenth century, the South had certainly become. Oliver Larkin considered the late nineteenth century South to be a place where "past realities had become present legends: the southern aristocrat gone forever and his plantation life...a theme for literary reconstruction... ." [6] This imaginary, moss-hung and moon-lit world was perpetuated by many who were not Southern at all.

The idea of the South as an exotic region passed by time insured, Larkin wrote, a "northern response to the idyllic and the pastoral" which permanently damaged national attitudes toward the old South culture. For better or worse, the popular culture image of the South which emerges from the late nineteenth century is of a place where the old regime remained firmly implanted, where the quaint customs and decorative styles so passionately adored by the Colonial Revival were indigenous and extant, and where a man could still get lost in backwater despite technological innovations elsewhere.

In a very elegant passage from his essay on landscape painting for *Art and Artists of the South*, the 1984 Robert P. Coggins Collection catalog, Bruce Chambers makes a fascinating linkage between the symbolist concerns of the late nineteenth century and the romance of Southern culture. Speaking to the idea of the South as an exotic other, as a refuge from the demands of progress, he lyrically describes the mood of the pictures at hand.

*I*n the landscape of the South as portrayed by these artists and by the artists who had preceded them in the 1870s and 1880s, such a sense of time does not exist. It is not even that the pace of time is more leisurely in the South; these dreamlike landscapes contain no sense whatsoever of the movement of time. What is perceived is a landscape outside of time, that could exist at any time, and therefore exists in none. The landscape recalls a more halcyon time, or a more primordial one, without specifying precisely when that occurred, if it occurred at all. It is, in this view, a kind of sanctified, mythic, immortal space free from the ravages of time and free, too, from the secular preoccupations of mortal man. It is a time, then, and a place instilled with grace which, if not demonstrably divine, was blessedly close." [7]

*T*ropical, cultivated, or primordial, these landscapes provide an alternative to the national mood of abundance, prosperity and an ever-expanding horizon. They capture areas of the South that time has forgotten, Gothic corners left uninhabited though frequented by tourists as exotic locales. That the Southern landscape, in all its diversity, should lead us out the back door of the national psyche, is a pleasant enough thought. For it is there that we can see the weeds encroaching the croplands, the imperfectable other, the timeless trap that Gaia set to remind us that we are but visitors on a land which will thrive just as easily without our help.

1. Kenneth Clark, *Landscape into Art*, (London: Penguin, 1956), 8.
2. *Ibid.*
3. Joshua Taylor, *America as Art*, (Washington, D. C.: Smithsonian Institution Press, 1976), 30.
4. *Ibid.*
5. Earl A. Powell, "Luminism and the American Sublime," in John Wilmerding, *American Light: The Luminist Movement, 1859-1875*, (Lawrenceville, New Jersey: Princeton University Press, 1989), 69.
6. Oliver Larkin, *Art and Life in America*, (New York: Rinehart & Company, 1949), 236.
7. Bruce Chambers, *Art and Artists of the South: The Robert P. Coggins Collection*, (Columbia: University of South Carolina Press, 1984), 83.

George Edward Cook
c. 1860-1930

British artist active 1880-1905; studied with Arthur E. Pope in England; spent the greater part of his life in Europe; died, Southern Pines, North Carolina.

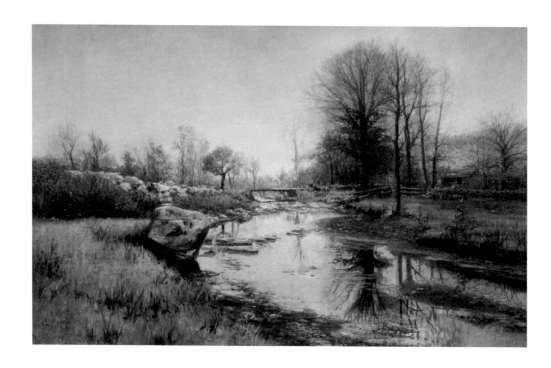

Untitled Landscape
 1892
 Oil on canvas
 27 x 47 inches
 Morris Museum of Art,
 Augusta, Georgia
 1996.022

Though little is known of Cook's art or career, this scene in North Carolina gives evidence of a tonalist view of a Southern scene. Like artists in the tradition of the Salmagundi Club in New York during the same period, Cook has chosen to emphasize the low contrasts and atmospheric setting of the scene rather than crisply outlining and detailing each part.

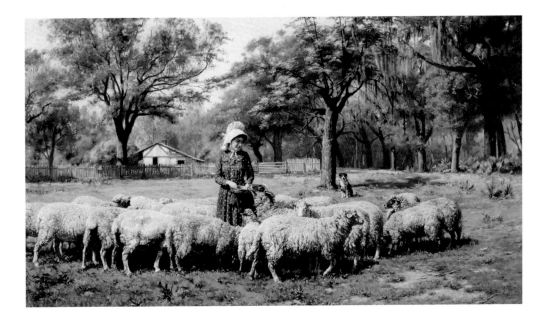

John Martin Tracy
1843-1893

Born, Rochester, Ohio; studied at the Ecole des Beaux-Arts in Paris, France, early 1870s; active in California, Chicago, Paris, St. Louis, and Connecticut, c. 1870-1880; active in Ocean Springs, Mississippi, c. 1889 until his death.

A Shepherdess
undated
Oil on canvas
30 x 50 inches
Morris Museum of Art,
Augusta, Georgia
Gift of Morris
Communications Corporation
1995.024

During his final years, Tracy, best known for his images of dogs and horses, resided on the Gulf Coast. While there, he seems to have painted at least one work based on a local setting. This work combines the more pastoral elements of European art in the Barbizon mood with a more distinctly American genre mentality. Tracy's concerns were always with "genteel recreation rather than symbolic domination of the wild." [1] That mood is surely reflected in this scene of a quaintly dressed shepherdess moving with her flock through a moss hung grove. It is by the vegetation and the half-framed timber cabin in the background, reminiscent of Richard Clague and William Aiken Walker, that we can identify the scene as Southern.

1. Tom Davis, "In Search of John Martin Tracy," *Wildlife Art News*, September/October, 1994, 94.

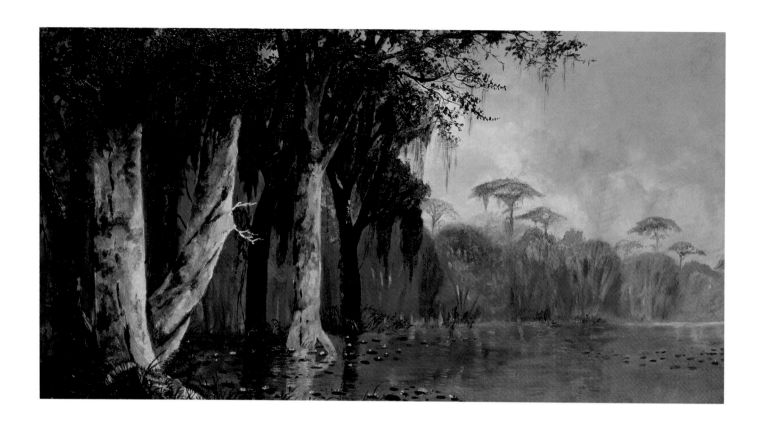

Joseph Rusling Meeker
 1827-1889

Louisiana Bayou
 c. 1885
 Oil on canvas
 20⅛ x 36⅛ inches
 Collection of the Montgomery Museum of Fine Arts, Montgomery, Alabama
 Montgomery Museum of Fine Arts Association Purchase

Lost Horizons:

the exotic sublime of Louisiana wetlands

Distinctions in attitude toward the lower Mississippi River Valley, in particular the swamps of the great Yazoo and Achafalaya basins, are as dramatic as those between antebellum prosperity and post-bellum depression, or more symbolically, between antebellum romance and reconstruction decay. Prior to the war the river traffic in and around Natchez, Yazoo City and New Orleans afforded travel writers, novelists, social critics and painters with lively material. Tall tales of flatboatmen, gamblers and sharpshooters fill the annals of old Southwest humor. Perhaps more important, the area was distinguished by the great wealth of the cotton kingdom which made Natchez one of the richest cities of the day and New Orleans one of the most important ports. With the war and Reconstruction, all that changed.

Edward King, a northern journalist of moralizing nature, took one of the first extensive looks at the post-war South in his "record of journeys," *The Great South*, published in 1875, one year prior to the end of Reconstruction. Setting a tone of darkness and light, he writes of Louisiana as "Paradise Lost," seeing upon "its bayou-penetrated soil, on its rich uplands and its vast prairies, a gigantic struggle," a battle of the "picturesque and unjust civilizations of the past with the prosaic and levelling civilization of the present."[1]

While admitting that the "nightmare of civil war has passed away," he finds all efforts at "re-establishing the commerce of the State" to be most "disheartening and depressing." Though admiring the remnants of the French, Spanish and Creole cultures, and anxious that the agrarian classes, black and white, should re-establish a prosperous economy, he is not optimistic. "The past has given to the future the dower of the present; there seems only a dead level of uninspiring struggle for those going out, and but small hope for those coming in."

King's sociology, and his analysis of Reconstruction inequity in Louisiana may be of little interest by this date. However, the popular culture mythology he accepts envisions a prosperous, optimistic and expansive northeastern culture set against a devastated South struggling to recover, an exotic terrain outside consensual attitudes of what is "American." It is this terrain, this "tract of hopelessly irreclaimable, grotesque water wilderness, where abound all kinds of noisome reptiles, birds and insects" which attracted several of the landscape painters under consideration in this exhibition.

This is not the landscape of opportunity. King despairs that "as far as the eye can reach you will see hundreds of ruined trees, great stretches of water, forbidding avenues which seem to lead to the bottomless pit, vistas as endless as hasheesh visions; and the cries of strange birds, and the bellowings of the alligator" are "the only sounds from life." As if describing a gallery viewing, he sighs that one "will be glad to steal back to the pure sunlight and the open lowland, to the river and odor of many flowers." Pictorially, this would be like going from a gallery in which one gasped over one of Moran's Grand Canyon paintings only to falter when seeing one of Joseph Rusling Meeker's "Evangeline" paintings with their intimations of lost love and treacherous passage.

Still, King didn't discover this landscape, he merely articulated a high Victorian response, a "key to unlock the poetic magic that can transform a carefully transcribed piece of scenery into a moving aesthetic experience."[2] His literary effort had been preceded for more than ten years by several artists, native and itinerant, who had worked the scene at great length.

As with the antebellum portrait tradition, the visiting artist and the local practitioner afford different views. Richard Clague, a member of the New Orleans Creole ascendancy, returned from France to the Crescent City with a Barbizon spirit. His pupils, William Henry Buck and Marshall J. Smith perpetuated his atmospheric style in their depictions of solitary cabins by Lake Pontchartrain, rutted, water-filled roads on the way to shabby plantation houses, and isolated lakes and ponds surrounded only by towering live oaks draped with Spanish moss. Following Clague's death Marshall Smith's father purchased the artist's sketchbook for his son. Young Smith created several works based on Clague's compositions, perfecting a minute brushy surface of slashing gray color often laid down over a field of red. His contemporary, William Henry Buck, abandoned a modest career as a cotton factor to produce atmospheric landscapes of a more formulaic nature.

Of all the artists who sought to capture the enigmatic quality of the Louisiana wetlands, only Meeker left an extended written record. In three articles published in the St. Louis *Western* between 1877 and 1878, he outlines an aesthetic which acknowledges the seventeenth-century Claudian tradition, looks back more recently to Turner, and whether consciously or not, evokes the language of tonalism.

With Ruskinian evangelic fervor, he finds in Turner a true master of "grand composition." Following earnest Victorian aesthetics, Meeker acknowledges the artist's craft, while praising his higher achievement in "the quality of unity, which dissipates all crudeness, causes an harmonious juxtaposition of light and dark, and compels all lines in the picture to flow so gently one into the other that the eye shall receive no offense."[3]

Plucking out the offended eye is stayed by an area of repose in each grand work. This area is "disposed" by color "to produce the utmost harmony; and the major and minor lights and shades are so arranged that the tone of the work shall give a satisfying sense of completeness...." It is this element of tone that gives the work a "final element of repose beyond all."

Meeker's tonalism is most apparent in the minute range of trees and vegetation in the rear ground of his tripartite planar field. These are often rendered in complementary tones of gray and green, vaguely brushed to enhance the sense of humid weightiness. However, this technique is not meant to serve the purposes of trompe l'oeil impressionism, bur rather to realize the larger goal: the creation of a "quality of mystery."

This quality of mystery is the property of "all great Art, and is quite...essential...to the completeness of a picture...." Gradations of light and shadow, affirmation of recessing vista, and investment of narrative detail all serve this mysterious quality. Mystery is the seductive lure to the viewer's eye to enter another world, for "by the use of mists and nimbus clouds lending obscurity to portions of the picture" we experience something suggestive of more than can be seen, making us wish to explore half hidden horizons. In this element of mystery lies much of the poetic sentiment of a work of Art" without which the artist cannot "truly inspire the soul with lofty aspirations...."[4]

1. Edward King, *The Great South: A Record of Journeys in Louisiana*, (Hartford, Connecticut: American Publishing Company, 1875), 34.
2. W. F. Axton, "Victorian Landscape Painting: A Change in Outlook," in *Nature and the Victorian Imagination*, (Berkeley: University of California Press, 1977), 292.
3. Joseph Rusling Meeker, "Some Accounts of Old and New Masters," *The Western*, 1878, p. 73.
4. Ibid.

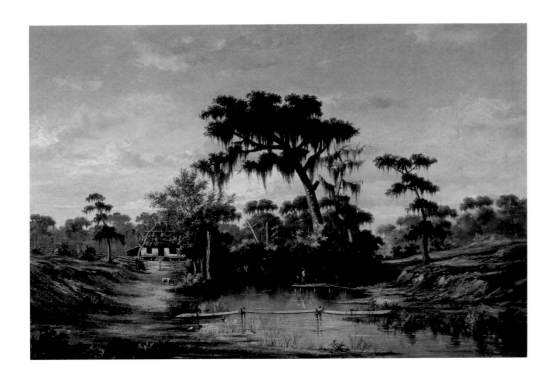

Louisiana Pastoral: Bayou Bridge
 c. 1880
 Oil on canvas
 26 x 40 inches
 The Ogden Collection, New Orleans, Louisiana

William Henry Buck
1840-1888

Born, Bergen, Norway; studied in Boston, and with Ernest Ciceri, Richard Clague, Andres Molinary and Achille Perelli; exhibited at Seebold's Art Gallery, with the Southern Art Union, of which he was Director in 1882, and notably, at the Cotton Centennial Exposition in 1884-85; active in New Orleans as a painter and restorer, 1869-1888; died, New Orleans.

Richard Clague
1821-1873

Born, Paris, France; studied with Jean C. F. Humbert, a student of J. A. D. Ingres, in Geneva, Switzerland, and at the Ecole des Beaux Arts in Paris, 1849; thought to have exhibited in the Parisian Salons of 1848-49 and 1853 as well as in commercial galleries and the Grand State Fair of Louisiana in 1871; well known as a portraitist as well as a landscape painter; died, Algiers, Louisiana.

Clague is the most fascinating and most influential of the Louisiana landscape painters. Like other members of the Creole ascendancy, he was thoroughly acquainted with life in France, having moved with his family between New Orleans and Paris. At his father's death in 1836 he became rather prosperously independent and undertook a study of art. His next twenty years seem to have been spent largely in France, during the time when Jean Francoise Millet and others were working in the Barbizon forests. He was sufficiently aware of trends in French artistic and exploratory circles to have accompanied the de Lesseps expedition to the Suez from November, 1856 to March, 1857. [1]

When the Civil War broke out he enlisted in the Confederate Army, in which he served quite briefly. Following the losses of the war, and his personal fortune, he undertook a self-imposed exile in the trans-Mississippi backwater of Algiers. It was during this brief period before his death in 1873 that his best known works were created, including the series of drawings so inspirational to Marshall Smith. [2]

Clague brings to the art of the swamp and the bayou an atmospheric sensibility clearly inspired by the Barbizon mood. The sociology of this movement was highly democratic and distinctly outside formal academic concerns. The "return to natural truth" in this style, "memorializes essential verities of the natural world in the face of accelerating change...." [3] This is altogether in keeping with the idea of the South as an exotic other, especially the more remote areas of Louisiana. There, Clague, like George Inness only slightly later in Florida, could create a "private Eden from an assemblage of idea and actuality that went far beyond simple pastoral pleasantries."

In works like *Back of Algiers*, he glazes Barbizon scenes of rural simplicity with the damp sheen of semi-tropical moisture and the dense green of a lush and riotous vegetation. These are works which offer to be felt, as well as seen. Of all the artists in the region during the period, his achievement was the most sophisticated, perhaps because it was clearly in the most identifiable European high style, but also because as an artist he was a master at applying paint and glazes to achieve a sense of place far richer than the more formulaic approach of many of his contemporaries.

1. John A. Mahe II and Rosanne McCaffrey, eds., *Encyclopedia of New Orleans Artists 1718-1918*, (New Orleans, Louisiana: The Historic New Orleans Collection, 1987), 78.
2. See Roulhac B. Toledano, *Richard Clague, 1821-1873*, (New Orleans, Louisiana: New Orleans Museum of Art), 1974.
3. Peter Bermingham, *American Art in the Barbizon Mood*, (Washington, D.C.: Smithsonian Institution Press, 1975), 49.

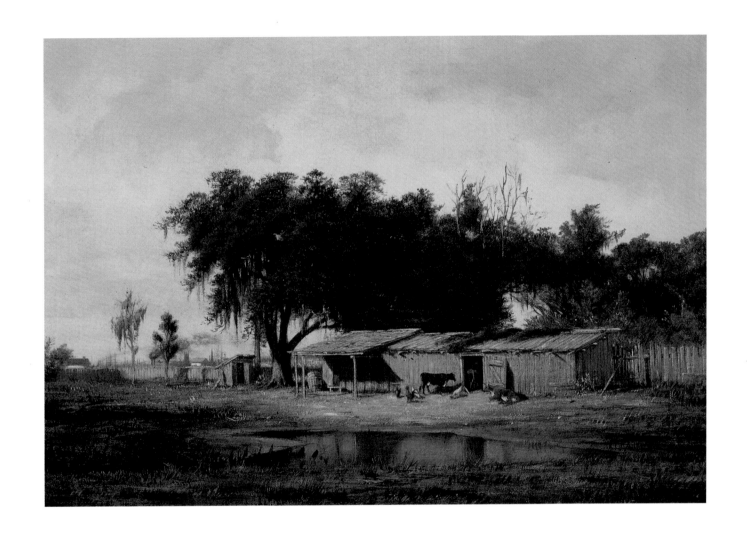

Back of Algiers
 c. 1870-1873
 Oil on canvas
 13¾ x 20 inches
 New Orleans Museum of Art
 Gift of Mrs. Benjamin M. Harrod

George David Coulon
1822-1904

Born, Seloncourt, France; immigrated to New Orleans with his parents in 1833; studied with several prominent antebellum New Orleans artists, including Francois Fleischbien and Jacques Amans, two of the premier Franco-Creole portraitists; apprenticed with Leon Pomerede in 1839 as a muralist, assisting with painting the Transfiguration for St. Patrick's Church; exhibited extensively in New Orleans, especially at Wagener's, the Artists' Association of New Orleans, and the Southern Art Union, where he was also a noted instructor; active throughout his career in New Orleans; died, New Orleans.

Though a far less inventive artist than many of his contemporaries, Coulon was the grand old man of the New Orleans art world in his day. Always willing to experiment, and possessed of a most fanciful imagination, he copied chromolithographs, developed a technique for hand coloring photographs with the photographer John Hawley Clark, and delighted in the details of clothing and jewelry in his extravagant bourgeois portraits.

Many of his landscapes are rather formulaic depictions of romantic swamps and bayous, for which, considering the quantity of extant examples, there must have been a considerable demand. These often have a pronounced blue-green tonality, an enticing vanishing perspective, and a "romantic" sense of place.

At the time this painting was completed, Coulon's son, the artist George Joseph Amede Coulon, was conducting a lengthy journey through the Louisiana wetlands, making photographs, sketching sites for future landscape paintings, and taking notes for the subsequent book, *350 Miles in a Skiff through the Louisiana Swamps.*[1] Perhaps his son provided the inspiration for this work, a view of the downriver scenery in New Orleans.

Bayou Beauregard is a most unusual work for Coulon. In this scene he does not depend upon a formulaic vanishing perspective to lure the viewer into the scene. The colors of the sky and the tonality in the water suggest a lingering luminist affection moderated by a tonalist sensibility of close color harmonics. The lone figure in the skiff, and the heron in flight, magically reflected in the water below, affirm the loneliness of the scene so richly laid out parallel to the picture plane.

1. John A. Mahe II and Rosanne McCaffrey, eds., *Encyclopedia of New Orleans Artists 1718-1918,* (New Orleans, Louisiana: The Historic New Orleans Collection, 1987), 88.

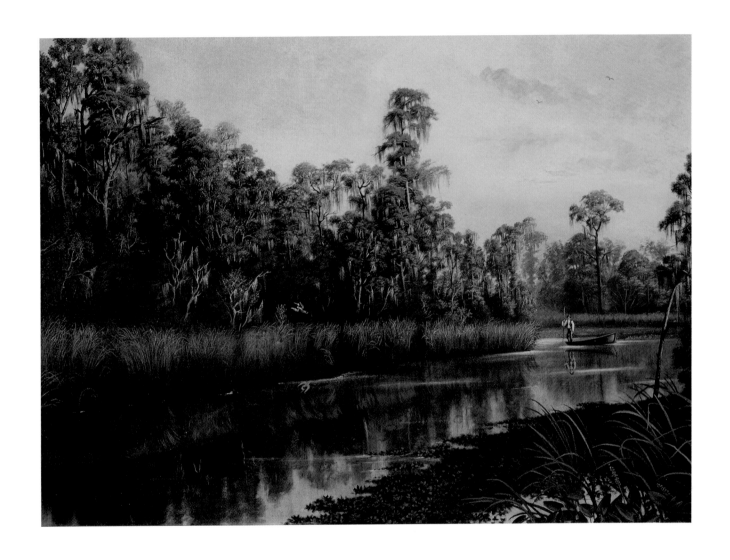

Bayou Beauregard, St. Bernard Parish
 1887
 Oil on canvas
 24 x 33 inches
 The Ogden Collection, New Orleans, Louisiana

Joseph Rusling Meeker
1827-1889

Born, Newark, New Jersey; studied at the National Academy of Design with Asher B. Durand; exhibited at the American Art Union and the National Academy of Design; active in Louisville, Kentucky, 1852-1859, made sketches of the Yazoo River in Mississippi, and the Mississippi wetlands of Louisiana while serving on a Union gunboat during the Civil War, 1862-1865; thought to have made intermittent sketching expeditions to the same areas between 1865 and 1875; died, St. Louis, Missouri.

Meeker applied his lofty theories of art to a series of works inspired by the actual terrain of Louisiana, and given didactic meaning by the myth of Evangeline the Acadian ("Cajun") wanderer made famous by Henry Wadsworth Longfellow. Having served on a Union gunboat in the lower Mississippi River Valley during the war, he experienced the swamps first hand, making several sketches of what he saw. Many of his subsequent paintings explore the mystery and wonder of remote watery settings, lit by a dramatic unearthly light.

Within that setting he sought Evangeline as earnestly as she sought her Gabriel. A Meeker work in the Morris collection recalls that same saga. Against a backdrop of glowing sunset and murky swamps, a single pirogue has drifted against a small island. The solitary figure standing to the right recalls Gabriel, a "Voyager in the lowlands of Louisiana," where the "towering and tenebrous boughs of the cypress/Met in a dusky arch," creating an atmosphere "dreamlike and indistinct..." Could this be his boat? Was it through "those shadowy aisles" that "Gabriel wandered before her?"

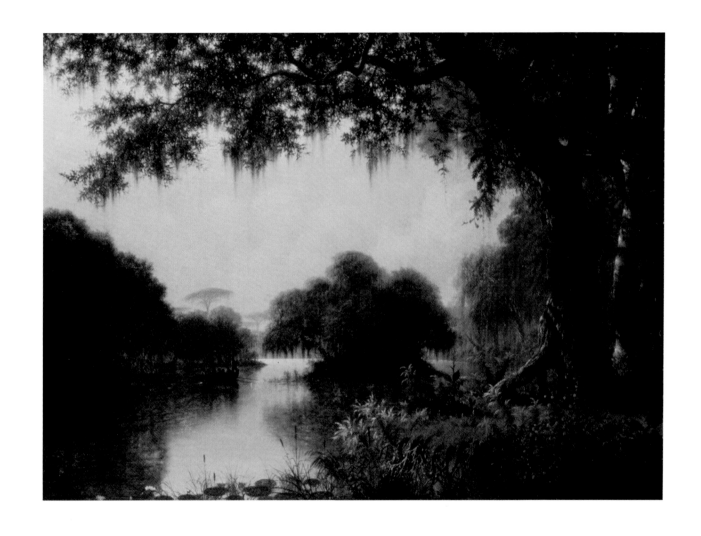

The Acadians in the Achafalaya, "Evangeline"
 1871
 Oil on canvas
 32⅛ x 42³/₁₆ inches
 Brooklyn Museum of Art, Brooklyn, New York
 A. Augustus Healy Fund, 50.118

Marshall Joseph Smith, Jr.
1854-1923

Born, Norfolk, Virginia; studied with Richard Clague in the years immediately after the Civil War, and in Munich, 1876-1877; active in New Orleans throughout his career; founding member of the Southern Art Union, 1880; exhibited at Seebold's, 1874, the Southern Art Union, 1881, and the Artists' Association of New Orleans, 1889-1890; died, Covington, Louisiana.

*I*n the years following the Civil War, Smith's family was prosperous enough to indulge him in an interest in art, notably a period of "study" with Richard Clague. But his most fascinating connection with Clague occurred when his father purchased a group of Clague's drawings at the estate sale following the artist's death. These were used by young Smith as compositional sources for several paintings still extant, notably those in the Ogden Collection in New Orleans. [1]

Smith's trip to Munich in 1876-1877 is equally noteworthy. The art academy in Munich, whose royal patron King Ludwig had guaranteed its success, was attracting several Americans. William Merritt Chase, Frank Duveneck, and Smith's ultimate colleagues in New Orleans, the Woodward brothers, all studied there. The Munich School encouraged a somber tradition of light and shadow which recalled the Dutch old masters of the seventeenth century.

Smith's image of a bayou plantation is one of the more important documents of art from the period. This is no romantic scene of a plantation created to satisfy the tastes of the colonial revival inspired by the Philadelphia Centennial of 1876. Unlike Edward Lamson Henry, Smith does not create a landscape with a romantic glow implicit with sentimental narrative undercurrents. It captures the spirit of King's *The Great South*, a record of a previously prosperous agrarian culture now in marked decline. This is also a work that combines a naturalistic response to the scene at hand with very deft brushwork. The shimmering effect of the surface, achieved by tiny brushwork over intermediate grounds of deep red, make it a very evocative statement of the Louisiana scene in decline.

Quite unlike anything else being painted at the time, and actually rather unlike Smith's other work, it demonstrates Smith's ability to take up the brush of naturalism in Louisiana from Clague. Unfortunately, Smith's wealth enabled him to take a more leisurely approach to his art and he spent his last years deeply absorbed in the designs for Mardi Gras festivities. [2]

1. This collection was given by the Smith family to the New Orleans Museum of Art and is partially reproduced in Roulhac Toledano, *Richard Clague 1821-1873*, (New Orleans, Louisiana: New Orleans Museum of Art, 1974).
2. See Historic New Orleans Collection Artist's Files for secondary documentation on Smith's life and career in later years.

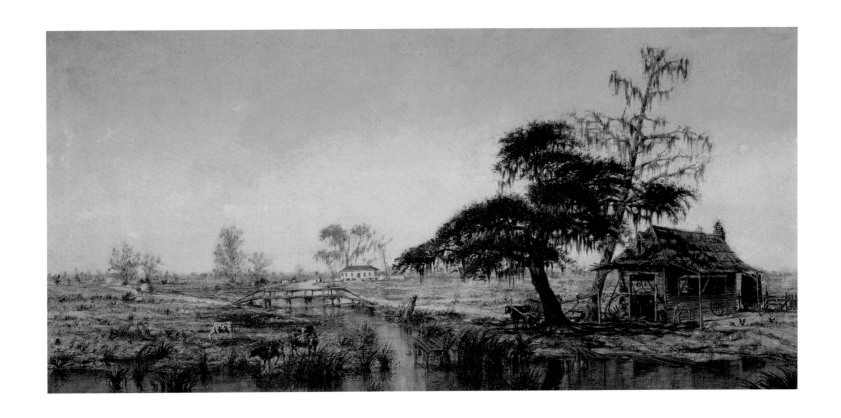

Bayou Plantation
 c. 1879-1900
 Oil on canvas
 17 x 36¼ inches
 New Orleans Museum of Art
 Gift of William E. Groves

William C. A. Frerichs
1829-1905

Born, Ghent, Belgium; studied at the Royal Academy in the Hague, The Netherlands; immigrated to New York, 1850; active in western North Carolina, 1855-1863, thereafter in New York and New Jersey; died, Tottenville, New York.

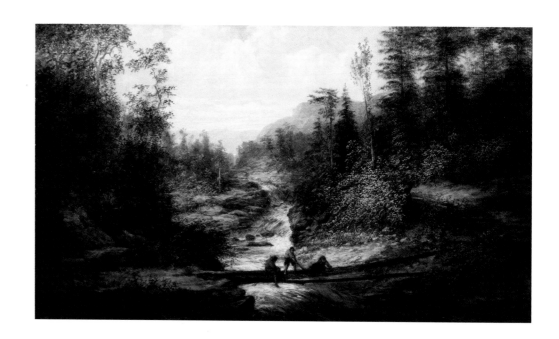

After the Storm
 c. 1870
 Oil on canvas
 26 x 44 inches
 Courtesy of Mr. and Mrs. William S. Morris III

Forests Primeval:
the Southern Highlands

No more radical change of scene can be envisioned than a move from the fetid air and impenetrable swamps of Louisiana to the cooler air, mountain passes and cultivated valleys of the Southern highlands. In the late nineteenth century this region came to be seen as a time capsule of rural virtues and quaint conditions, inspiring to writers, artists and the first generation of scenic photographers.

Before the Civil War, and during the height of the conflict, W. C. A. Frerichs, a European landscape painter, worked in western North Carolina and eastern Tennessee. Alone of the artists in this exhibition Frerichs had direct exposure to the Hague School of landscape painting in the Netherlands. The Hague School style looked back to the shadowed dramatics of such seventeenth century masters as Jacob van Ruisdael and Jan van Goyen. At the same time, the Hague school artists, notably Jacob Maris and Anton Mauve were very familiar with developments on the Barbizon scene in France.

Frerichs' studies at the Royal Academy in the Hague are critical to an understanding of his technical style. He came to America and began painting in the South at a time when there "was evidently a general predilection for things Dutch which can explain in part the international acclaim for the distinctively Dutch character of the work of the Hague School."[1]

Like the Dutch old masters, his works are often heavily glazed, brushed with sparks of vivid color laid down upon sober backgrounds. As Benjamin Williams poetically observed, the "beauty of billowing clouds broad-shadowed on the flat Dutch landscape, the lingering, lucid northern light, the shifting dune valleys near Scheveningen beach, the complicated solutions of light on water..." were part of Frerichs' artistic heritage.[2]

Frerichs applied that heritage to the Appalachian Piedmont region. He is amongst the few mid-nineteenth century artists to have worked in this region of the South. In western North Carolina, along the French Broad and in the Tennessee Smokies, Frerichs found a vast, isolated landscape which he sketched and painted on site. In many of his works Frerichs sought to capture the depth and perspective created by the views of mountain streams and rivers penetrating the rocky ranges. Often genre elements, such as youths playing upon a fallen tree trunk spanning the stream, bring a small note of humanity to the vastly overwhelming scene, a glimpse of the Southern sublime.

His work varies in style from the calm of German romantic luminism to the stormy, splashy, brushy works partly inspired by Jacob van Ruisdael's dark scenes of cemeteries and overgrown forests. These vast canvases capture the rush of streams and the threat of storm clouds over a landscape whose lofty scale affords an interesting counterpoint to the claustrophobic bayous of Louisiana.

The Southern highlands are a far more extensive area, with a richer variety of sections. Writing of the highlands in 1921, John C. Campbell defined them as inclusive of "the four western counties of Maryland; the Blue Ridge Valley, and the Allegheny Ridge of Virginia; all of West Virginia; eastern Tennessee; eastern Kentucky; western North Carolina; the

four northwestern counties of South Carolina; northern Georgia; and northeastern Alabama." [3]

Here, late in the first quarter of the twentieth century, Campbell could still be impressed by scenic wonders persisting "along lingering segments of that frontier line." What he most admired were those "distinctive social customs and standards of living, so interesting to many…" which provoke a "haunting, half-asked question of the connection between [these] physiographic and…natural causes."

As if describing a landscape by W. C. A. Frerichs, or C. C. Brenner, Campbell writes of the traveler who traipses the "trails of this far country, fords its rushing streams, and forces his way through thickets of rhododendron and laurel to rest upon some beech-shaded bank of moss, and who toward sunset checks his horse upon the ridge to trace the thread of smoke which signals welcome," a region of "echoes still sounding of half-remembered traditions, folk lore, and folk-songs, recited or sung before the fire…."

While Frerichs' work combines a European high style with a Southern locale, the art of C. C. Brenner speaks to those nostalgic longings of which Campbell writes. Brenner's art hails from and speaks to the popular culture passion for "old Kentucky" which persisted after the Philadelphia Centennial of 1876. The myth of old Kentucky was comprised of two distinct castes: the eastern Kentucky highlands and the central Kentucky plains. The mountaineers were regarded as "a people whose progress into time had been arrested, whose ways had somehow ceased to change." [4] Because their rough terrain had not welcomed the reforming tides of incoming settlers, they were "isolated, frozen into a pattern of life that reflected pioneer time."

By contrast, Ward writes, the "stereotype of the agricultural aristocracy of the Bluegrass and its very different set of cultural values" fostered the "philosophy that life was intended to be leisurely and comfortable and southern in its social graces; but the Bluegrass…had kept pace with change.…" Several Kentucky authors, notably John Fox, Jr. and James Lane Allen, perpetuated these notions in a series of highly popular novels.

These novels, like Brenner's paintings, speak to a late nineteenth century affection for "melodrama of so high a grade, so joyous an enthusiasm, and so compelling an interest" as to give the reader, or the viewer, "an hour of uncritical pleasure." This tendency to the pathetic fallacy, to investing nature with thought and feeling, is the ultimate trickle down effect of Ruskinian aesthetics. James Lane Allen writes of the woods of Kentucky in just such a mood. A "Kentucky sylvan slope has a loveliness unique and local. The foliage of Kentucky trees is not thin nor dishevelled, the leaves crowd thick to the very ends of the boughs, and spread themselves full to the sky, making, where they are close together, under-spaces of green gloom scarcely shot through by sunbeams." [5]

Such thoughts color the lens through which we see Brenner's somber images of winter or his pensive celebrations of October light and foliage. These are paintings which speak to affections which though now disused have not lost their associations with a basic element of Western cultural thought: the search for otherworldly repose, the path back to the garden.

1. Hans Kraan, *The Hague School*, (London: The Royal Academy, 1983), 115.
2. North Carolina Museum of Art, *William C. A. Frerichs, 1829-1905*, (Raleigh: North Carolina Museum of Art, 1974), unpaged.
3. Olive D. Campbell, *The Southern Highlands*, (New York: The Russel Sage Foundation Library, 1920). William S. Ward, *A Literary History of Kentucky*, (Knoxville: University of Tennessee Press, 1988), 78.
5. James Lane Allen, *The Blue-Grass Region of Kentucky and Other Kentucky Articles*, (New York: Macmillan Company, 1900), 11.

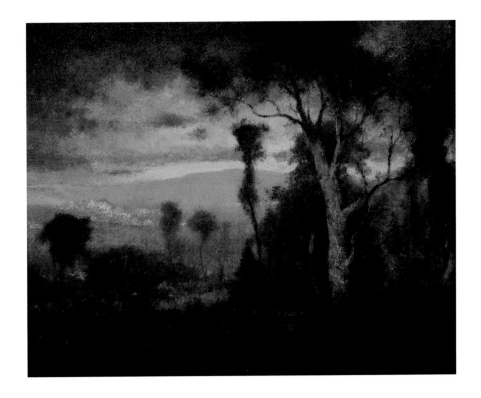

Elliott Daingerfield
1859-1932

Born, Harper's Ferry, Virginia (now in West Virginia); studied in New York with Walter Satterlee, at the Art Students League, 1880-1884, and with George Inness; active in Fayetteville, North Carolina, before 1880, and in New York City and Blowing Rock, North Carolina, 1886-1932; died, New York City.

Sunset Glory

c. 1915
Oil on canvas
27½ x 33¾ inches
Morris Museum of Art,
Augusta, Georgia
1990.014

The appeal of the highlands to Elliott Daingerfield is easily understood. Having spent his youth in North Carolina, Daingerfield became one of the most prominent American symbolist painters of the late nineteenth century, a master of monumental murals, easel paintings and an accomplished art critic. Like George Inness, Daingerfield believed and saw more beneath the surface of nature than the eye first beheld. The body of his work that treats the Southern landscape has a passionate intensity...much like the sky in his brilliant sunset whose burning tones pay homage to an earlier romantic sensibility even as the muted forms and textured brushwork seek an illusive poetics.

Carl Christian Brenner
1838-1888

Born, Bavaria, Germany; studied in Germany with Philip Froelig at the Academy of Fine Arts in Munich; active in New Orleans, 1854, and in Louisville, Kentucky, 1854-1888; exhibited at the Louisville Industrial Exposition, 1874, the Philadelphia Centennial Exposition, 1876, at the National Academy in New York from 1878-1886, and at the Pennsylvania Academy of Fine Arts, 1881-1885; died, Louisville.

Brenner and his family were part of that influx of German craftsmen, artisans, merchants and musicians which so greatly enhanced the cultural profile of several Ohio Valley and Mississippi river towns, notably Cincinnati, Louisville and New Orleans, in the years following the revolutions of 1848 and leading up to the Civil War. His father was a glazier and insisted that young Brenner learn a practical trade as well as skills as a landscape painter, an inclination he evinced as early as 1854, while sketching scenes of the Mississippi River on their upriver voyage from New Orleans to Louisville.

Initially a sign and ornamental painter, Brenner also kept a paint store until 1878 when he began to pursue easel painting full time. Surviving records from Brenner's annual public sales indicate his works sold in a range of $35 to $1000, modest sums even for those times. This may account for the melancholy Victorian description given of his life and early death by the legendary *Courier-Journal* editor Henry Watterson, who lamented that he did not receive "the sympathy and support from men of means and supposed art appreciation of Louisville to which is talent entitled him...."[1]

Brenner's favorite topic was the beech tree. As with his Louisville colleague Harvey Joiner he could be quite formulaic in his approach to the subject matter, rendering masses of trees in dramatic colorations registering deep shadows and glowing patches of sunlight. But Brenner was also known to have been a most enthusiastic artist *en plein air*, working in Louisville's Cherokee Park, in nearby PeeWee Valley and throughout Kentucky.[2]

Brenner's response to tonalism, late in his career, was an earnest indication of his devotion to his art. Between 1883 and 1886 several contemporary American and French masters, notably Corot, Daubigny, Inness, Eakins and Homer were on view in Louisville's Southern Exhibition. Justus Bier's observation that it was at this time that Brenner abandoned "the brown studio tones which appear in his landscapes of the 1870s" for "colors of nature truthfully observed" may been seen in the contrasting picture illustrated here.[3]

Brenner could be delightfully glib, and was not above admitting an inclination to enhance, as well as depict, nature. "Nature is not always in its most beautiful moods even in the same spot. The artist must be subjective as well as objective. He must draw from his memory and his heart experiences as well as from the scene before him." By adding a few personal touches of "slanting sunlight, mist, clouds and other circumstances" he believed the artist was capable of making "a hundred pictures" from one scene.[4] And so, it would seem, he did.

1. Louisville, Kentucky, *Courier-Journal*, October 16, 1879, as found in The Filson Club artists files.
2. Louisville, Kentucky, *Courier-Journal*, December 18, 1887, as found in The Filson Club artists files.
3. Justus Bier, "Carl C. Brenner: A German American Landscapist," *American-German Review*, April 1951, 24.
4. Louisville, Kentucky, *Courier-Journal*, December 17, 1878, as found in The Filson Club artists files.

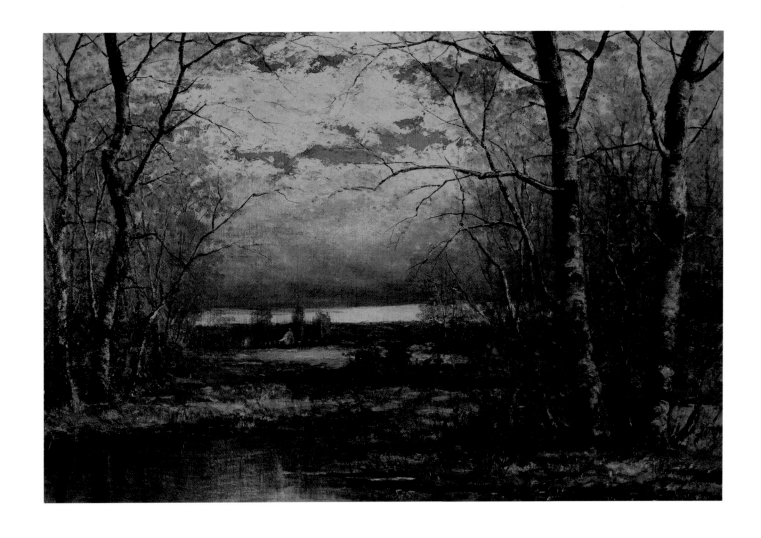

The Close of an Autumn Day

1885

Oil on canvas

14 x 20¾ inches

Collection of The Speed Art Museum, Louisville, Kentucky

Bequest of Mrs. Louise J. Steenman, 1950.2.6

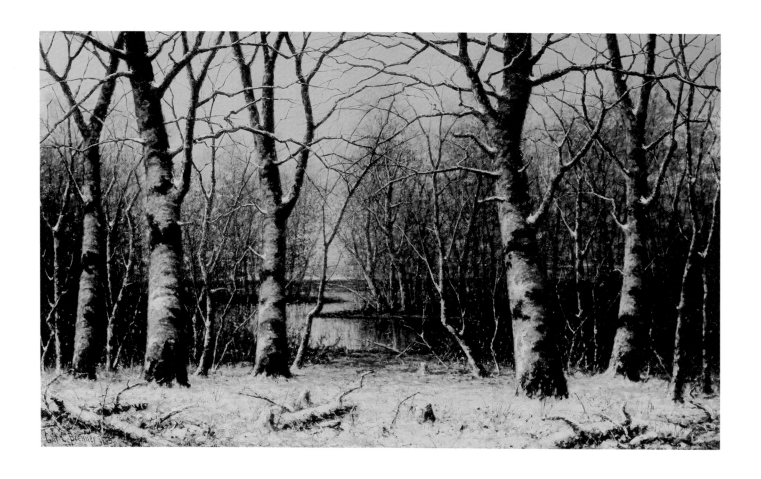

Carl Christian Brenner

Winter

　1885
　Oil on canvas
　30 x 51 inches
　Collection of The Speed Art Museum, Louisville, Kentucky
　Bequest of Mrs. Elizabeth M. Gray, 1958.24

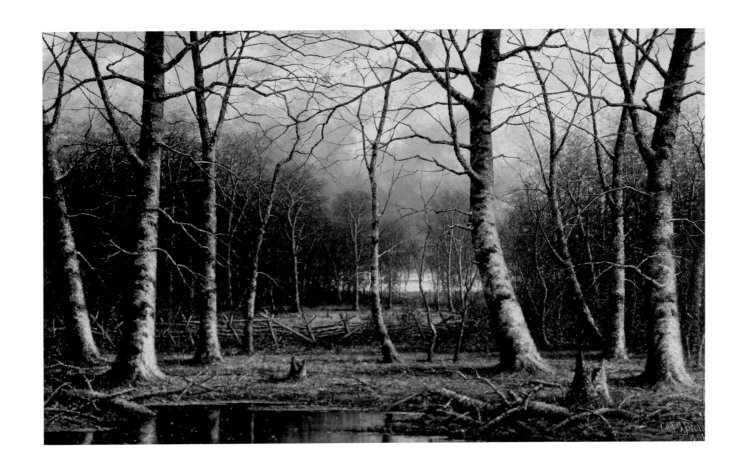

Carl Christian Brenner

Beechwood Trees
 1885
 Oil on canvas
 36 x 60 inches
 Cheekwood Museum of Art, Nashville, Tennessee

Harvey Joiner
1852-1932

Born, Charleston, Indiana; studied in St. Louis, 1874, with David Hoffman; active in Louisville, Kentucky, 1880-1932; died, Louisville.

Joiner's prodigious output of formulaic pictures set in deep gold shadow boxes depicting the eternally vanishing perspective point of an obtuse alley of trees in Cherokee Park, Louisville, have made him suspect of being an insignificant hack. Like William Aiken Walker and Alexander John Drysdale he knew a good crowd-pleasing technique that would keep him busy and prosperous.

However, he was also capable of creating works of lyrical color harmonics and evocative detail. The painting in the collection of the Morris Museum of Art would seem to be the largest and most accomplished of his oeuvre. Recalling Brenner's affection for beech trees, it is a work which draws the eye into an uninhabited interior stretching beyond the still waters of the woodland stream. The autumnal foliage of the paintings from the Clay collection are also an unusual departure from Joiner's more familiar grey-green-chartreuse palette.

Joiner appeared on the Louisville scene in Brenner's late days and took his place as the local landscape painter of choice. He was a long time resident of the *Courier-Journal* Building, and in the pages of that premier newspaper of the new South he was often lavishly praised for the very redundancies so irritating to contemporary critics. "A single tree, the trunk aslant, the strong sunlight striking the trunk or the lower branches, perhaps a bit of the path...these are the bits which are winning art recognition for Mr. Joiner." [1]

1. Louisville, Kentucky, *Courier-Journal*, December 9, 1900, as found in The Filson Club artists files.

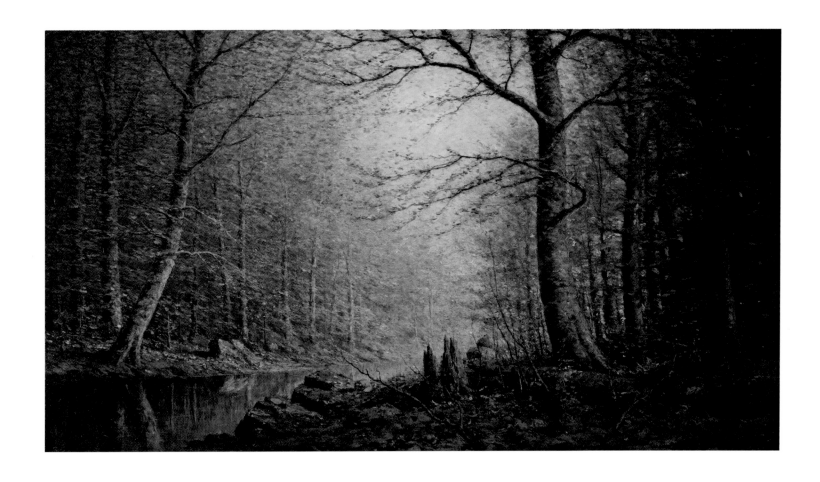

Wooded Landscape
 c. 1900
 Oil on canvas
 28 x 40 inches
 Morris Museum of Art, Augusta, Georgia
 1989.08.287

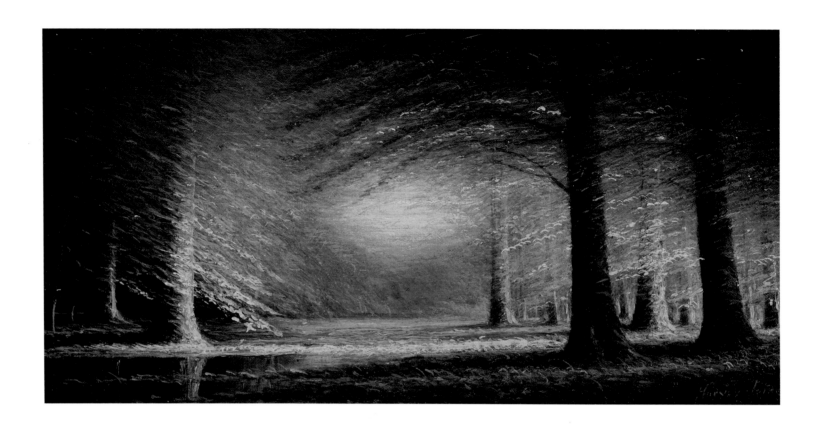

Harvey Joiner

Spring
undated
Oil on canvas
9½ x 19¼ inches
Courtesy of Isabel McHenry Clay
Photo: Mary Renzy, Lexington, Kentucky

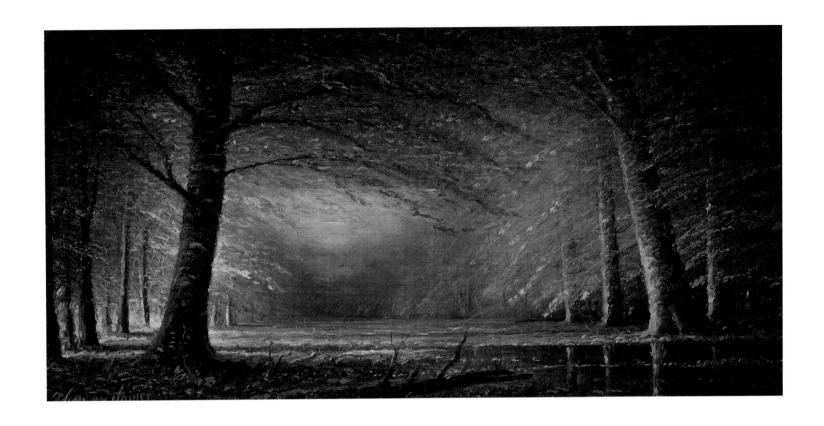

Harvey Joiner

Fall
undated
Oil on canvas
9¼ x 19⅜ inches
Courtesy of Isabel McHenry Clay
Photo: Mary Renzy, Lexington, Kentucky

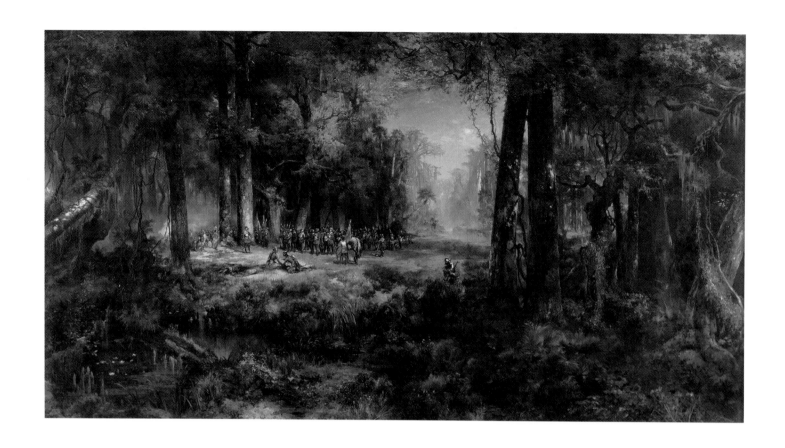

Thomas Moran
1837-1926

Ponce de Leon in Florida
1878
Oil on canvas
64½ x 115⅞ inches
Acquired for the people of Florida by the Frederick H. Schultz Family and NationsBank
Additional funding provided by The Cummer Council
The Cummer Museum of Art & Gardens, Jacksonville, Florida
Photo courtesy of SuperStock, Inc.

Tropical Glow:
the wetlands of Florida

On March 20, 1878, the *Boston Transcript* reported that Thomas Moran had "returned from Florida" where he had been visiting a wealthy patron in St. Augustine. Moran, the paper notes, "has brought back a portfolio full of sketches of Southern scenery, which is as different from the brilliant Yellowstone as possible." The artist, in what was surely one of the more astonishing conjunctions in late nineteenth century life, had "visited Harriet Beecher Stowe, at her orange grove, and hung from moon-lit balconies in old St. Augustine listening to the music of guitars and castanets." With irony unaware, the reporter notes that if Moran "puts all he saw on canvas, he will have some beautiful pictures."[1]

Certainly Moran is far better known for his gigantic canvases of canyons of the Yellowstone and of the Colorado, taking his place as one of the late luminists gone west. But he did create several works based on his Florida trip which place him amongst the first group of established American artists to work in late nineteenth century Florida. Like Albert Bierstadt, Moran combined a Ruskinian attention to the details of rock formations and mountain crevices with an implicit historical narrative.

Ponce de Leon in Florida which he created from his experience, is Moran at the top of his form as a history painter imbuing the American landscape with a near mystical significance. Indeed Moran's Ponce de Leon picture uses several of the artist's well honed pictorial devices...the fallen tree to the front left, the deeply penetrating perspective point slightly right of center, which closely resembles a canyon wall, and the small group of fig-ures clustered in the golden light of discovery in mid-field.

Though a wonderful fantasy, it did not meet with everyone's approval. William MacLeod, the Corcoran Curator of Art advising on the acquisition of the painting by the United States Congress, noted that he had received letters indicating that Moran's trees are "utterly unlike the timber of that state." He complained that "the live oak is black in bark, grows up straight, has enormous boughs, and that none of the trees represent the bark of Florida timber," while "the fallen birch is utterly absurd, as that tree is not known there. If this be so, the prospect of selling the picture is a poor one."[2] Moran eventually sold the picture, at auction, where it was passed along to the Ponce de Leon Hotel in St. Augustine.

Moran's rather dated allegorical response to the Florida frontier is charming, but hardly as profoundly site responsive as the works of his noted contemporaries Martin Johnson Heade and William Morris Hunt. Like other painters "lured to this tropical Eden of lush vegetation, by the exotic climate, by travel and sporting literature, by a sense of isolation and solitude, and often by myths of rejuvenation fueled by failing health" they "found in the Florida landscape imagery that was both beckoning and compelling."[3]

Ponce de Leon's search for a fountain of youth was finally realized in the late nineteenth century when Florida became one of the first great American tourists meccas. The transformation from a sparsely populated murky wetland into a glitteringly humid vacation ground for the wealthy of the robber baron era was surprisingly quick. St. Augustine, the old Spanish city

on the Atlantic was attracting visitors as early as 1870. By 1873 a St. Augustine Yacht Club had been organized to attract "wealthy people from New York, Chicago, and Cincinnati displaying diamonds, rich laces, velvets, and silks, similar to the sights at Saratoga at the height of the season."[4]

But it was the visit of Henry Morrison Flager, of Standard Oil, which was to cause the greatest transformation. Between his first visit to St. Augustine in 1883 and 1900 Flagler built hotels and the Florida East Coast Railway, connecting the north-east to the Florida Atlantic coast, all the way to Key West. In April 1896 Flager's efforts reached to Miami, creating another resort city. By the time Henry James visited he could affectionately refer to it as the "softest lap the South has to offer."

That Florida attracted a wide range of artists, some of whom played to the tourist trade and some of whom were seeking exotic locales as tourists, is apparent from a list of artists as diverse of Winslow Homer and William Aiken Walker. Walker painted several rather formulaic Florida sand dune paintings that he sold, along with his genre work, in the St. Augustine Hotels. William Morris Hunt, on the other hand, used the Florida landscape to paint works quite unlike anything yet seen in the American art world.

Florida also proved to be a last testament to the power of luminism, that fiercely compelling evocation of dramatic sunsets and sunrises, which characterized the Hudson River School. Martin Johnson Heade's Florida sunsets have a power rarely inspired by the Southern setting. Herman Herzog, working near St. Augustine as well, captured the dazzling light of bright Florida afternoons.

One of the most inspired luminist efforts to emerge from the Florida scene is by George Herbert McCord. McCord's *Sunset on St. Johns River* looks back toward the work of Frederich Edwin Church. A fascinating itinerant, McCord worked in England and America, traveling from the south coasts of Cornwall to New England, the Adirondacks, Florida and even on to California. Lack of a fixed residence throughout most of his career, and the broad scattering of his works, have made his biographical details very hard to secure.

McCord's painting could be read as an allegory on the demise of the St. Johns area as a calm refuge, eroded by the emerging tourist industry in Miami and on the Gulf Coast. "More rapid transportation facilities to the warmer climate of South Florida" huffs the great Virginian Branch Cabell "rather hastily removed from the St. Johns those rural and pleasingly bourgeois activities which, for half a century, had made this river so famous a factor in American life."[5]

Destination and terminus, the Florida landscape provides the site for dreams of a peaceful close to life as well as the locale for lifting off from life into the realm of space. "What Florida does is tie the South to the tropics...to in a sense metamorphose the old American Dream of Progress through manifest destiny into the new narcolepsy of sun and sand and retirement."[6] Small wonder that it is here that the sun still sets so gloriously.

1. Nancy K. Anderson, *Thomas Moran*, (New Haven, Connecticut: Yale University Press, 1997), 111.
2. William McLeod, April 29, 1878, curator's journal, Corcoran Museum of Art, as quoted in Nancy K. Anderson, *Thomas Moran*, (New Haven, Connecticut: Yale University Press, 1997), 111.
3. Ruth K. Beesch in *Florida Visionaries, 1870-1930*, (Gainesville: University Presses of Florida, 1989), 5.
4. Floyd and Marion Rinhart, *Victorian Florida: America's Last Frontier*, (Atlanta, Georgia: Peachtree Publishers Limited, 1991), 117.
5. Branch Cabell and A. J. Hanna, *The St. Johns, A Parade of Diversities*, (New York: Farrar & Rinehart, Inc., 1943), 273.
6. B. C. Hall and C. T. Wood, *The South*, (New York: Scribner, 1995), 365.

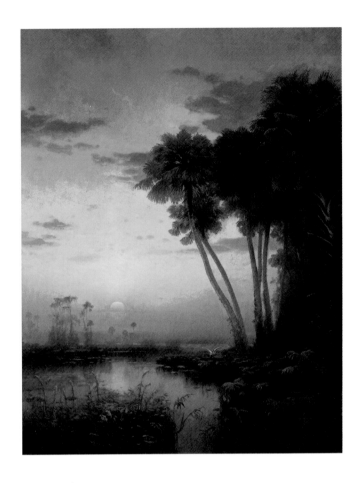

George Herbert McCord
1849-1909

Born, Brooklyn, New York; studied with James Fairman, 1866, and later with Samuel F. B. Morse; traveled extensively around the United States on sketching and painting tours, including several trips to Florida; exhibited at several regional competitions including the New Orleans Exposition, 1885; died, New York City.

Sunset on St. Johns River
1878
Oil on canvas
34 x 26 inches
The Ogden Collection
New Orleans, Louisiana

"Florida's image in paintings" created by a small group of late practitioners of luminism, "went beyond the merely representational. Heightened by imagination, myth, mysticism, romance and poetic tranquility, and influenced by beliefs and yearnings, this era was inspired by a created image of reality that was truly visionary."[1]

1. Ruth Beesch in *Florida Visionaries, 1870-1930,*
 (Gainesville: University Presses of Florida, 1989), 9

Herman Herzog
1832-1932

Born, Bremen, Germany; studied in Dusseldorf, with Andreas Achenbach, 1848; immigrated to America, c. 1868; settled in Philadelphia where he exhibited at the Pennsylvania Academy of Fine Arts, and at the National Academy of Design in New York; active in Gainesville, Florida; place of death unknown.

*H*erzog's long career was always dominated by his early training in the German Romantic tradition at the Dusseldorf Academy. Dusseldorf had also been a magnet for several other artists who rose to prominence in 19th century America including Albert Bierstadt and George Caleb Bingham. Considering the close affinities between the literary and artistic sensibilities of German Romanticism as espoused by Goethe, Caspar David Friedrich and Schinkel, it is not surprising that much of Herzog's work has a luminist feel reminiscent of the first generation of Hudson River School painters.

"Of his Florida paintings," Herzog "is at his expressive best in those which capture the shifting relationship between water and light." 1

1. E. Michael Wittington, in *Florida Visionaries, 1870-1930*, (Gainesville: University Presses of Florida, 1989), 31

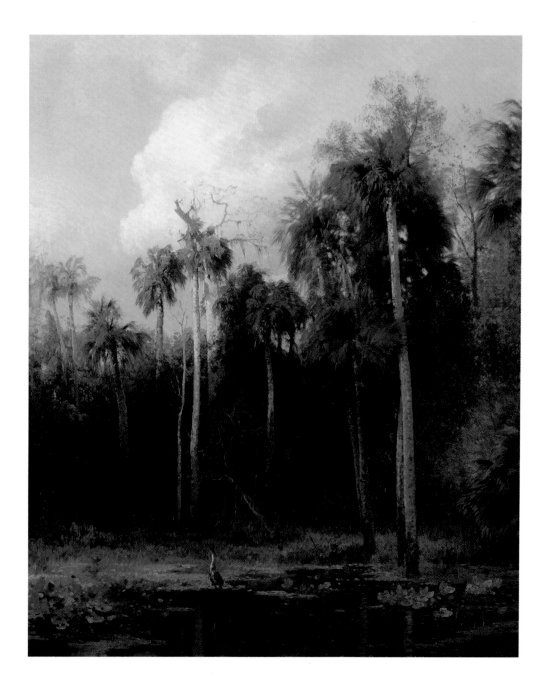

Forest with Heron
 undated
 Oil on canvas
 39 x 32 inches
 Lent by Dr. and Mrs. David A. Cofrin
 Courtesy of the Harn Museum of Art,
 University of Florida, Gainesville, Florida

William Morris Hunt
1824-1879

Born, Brattleboro, Vermont; studied at Harvard University, 1840-1844; traveled abroad, studying at the Dusseldorf Academy, 1845-1846; with Thomas Couture and Jean Francois Millet in France, 1846; intermittent visits to Florida, 1872-1875; drowned, Isle of Shoals, New Hampshire.

Not only was William Morris Hunt the most revered painter of his day in Boston, he was also one of the principal conduits for the introduction of the Barbizon mood into American art circles. The Hunts were a prosperous and prestigious New England family, his father having been a congressman, and this background gave him very early opportunities to study art. After his father's death he left Harvard in 1844 and began the first of several periods of study abroad.

Although initially enrolled in the Dusseldorf Academy, Hunt had a very negative reaction to the Dusseldorf traditions, finding the highly demanding academic approach much too stilted for his own sense of art. From the outset Hunt would seem to have regarded art as a vehicle for expressing a deeply personal response to nature rather than an exacting craft of demanding mimetic detail. He said, quite simply, "The artist is an interpreter of nature...."[1]

Following his departure from Dusseldorf he landed in Paris where the textured surfaces of Thomas Couture and the golden toned reveries of everyday life as painted by Jean Francois Millet inspired what became a life-long admiration for French naturalism. Studying with Couture and working at Barbizon with Millet for two years, Hunt was an enthusiastic respondent to trends in the Barbizon style, admiring in Jean Francois Millet and N. Diaz de la Peña an art "based on imagination, memory, and brilliant technique."[2]

Hunt's aesthetic sensibility, and its application to the Florida wilderness, provides a very

seemly pause for an art historical moment. As much as any other artist in this exhibition, Hunt represents the willful change in the artistic imagination demonstrated in the great shift in painterly style from the vivid coloration, slick surfaces and high minded subject matter of the first half of the nineteenth century toward those late nineteenth century expressions which we may, with some clear definition, call naturalism.

Naturalism's concerns are not only with subject matter of a far more approachable nature (peasants working in the fields as opposed to gods, goddesses, or all too human emperors winning battles), but also with the manner in which that subject is represented. Millet's appropriation of the working class as subject matter is neither revolutionary nor unexpected. The northern European tradition, especially in Holland, is ripe with genre images of the working class and the bourgeoisie. Furthermore, as Millet himself was the son of peasants, his flight from the artificiality of the Parisian art world led to residence in a setting not unlike that of his origins, albeit a return with a vested artistic authority. But with that return he brought a new lens, an ability to paint a rustic subject with an ingratiating touch and rich broken color...."[3]

The parallels between what Kenneth Clark calls Millet's conversion and Hunt's conversion are most striking. Although the patrician Hunt and the willing peasant Millet came from very different social realms, they shared a deep belief that art should proceed from personal feeling and not from those collectively sanctioned

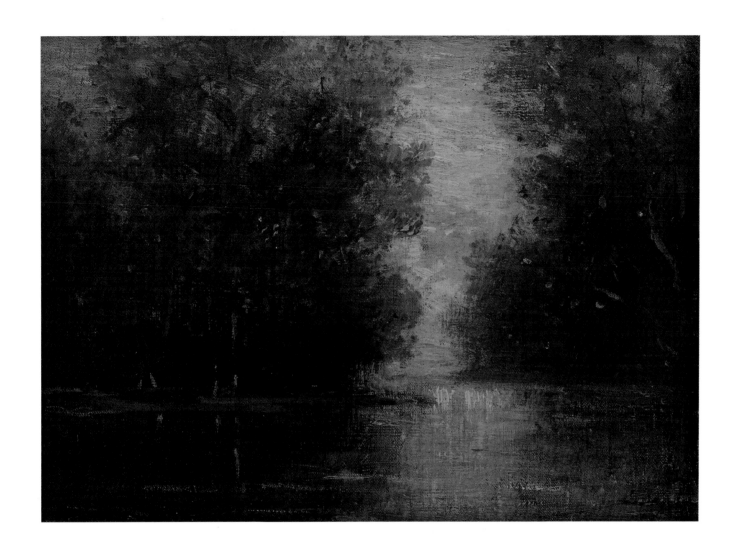

Sunrise, Florida
 c. 1874
 Oil on canvas
 10 x 16 inches
 Courtesy of the Sam and Robbie Vickers Florida Collection

virtues adored by the academies, and this is the great shift represented by naturalism. Increasingly, in this late nineteenth century, the naturalist imagination favored more exotic locales, more human subject matter, and more obviously passionate brushwork than previously seen.

In Boston, Hunt faced an artistic community that was just as deeply conservative as that Millet faced in Paris. Millet and Hunt also faced a landscape tradition that not only elevated the landscape to exalted levels of reverie but also demanded a verisimilitude of detail which could sustain high minded notions of "truth in art."[4] These stilted notions of truth were among the prevalent values of social consensus being challenged by the sweeping tides of liberalism in America and Europe, culminating in the abolitionist movement and the revolutions of 1848. But they were also being assaulted by the introduction and rapid rise of photography as a documentary medium.

Hunt was then in the very vanguard of a truly radical change in the meaning and representation of art. The "inductive ideal of pure observation has proved a mirage in science no less than in art," E.H. Gombrich writes, as "the very idea …that you can make your mind an innocent blank on which nature will record its secrets," is one of the fallacies of intellectual investigation in the west.[5] Hunt, especially as recorded in his published *Talks on Art*, communicated to his students the radical belief that an artist was not a documentarian but rather expressively distinct in the creative act.[6]

That Hunt should come to apply his aesthetics to the Florida scene is one of the wonders of the period under study. A disastrous fire in Boston in 1872 destroyed much of the artist's work and his collections of French paintings. He then traveled to Florida to visit a resort near Jacksonville where he not only painted but made the large vivid charcoal sketches he used for subsequent studio work.

Hunt's preference for the more somber, naturalistic colors of the Barbizon mood give his work a brooding quality well suited to his depictions of the Florida wilderness. He was visiting there in the days before Flagler made it a premier resort community, indeed at the time of his visits, Florida represented precisely that exotic other, on the east coast, which has provoked most of the commentary in this work.

Hunt's somewhat mystical, inaccessible spirit makes his Florida paintings a perfect contrast to Herzog and McCord's romances, which seek to dazzle the eye with the wonders of a frontier landscape on the edge of a booming America, in living color. Hunt's work is more wary, echoing the distinctions between Alfred, Lord Tennyson's concept of "nature red in tooth and claw" and Longfellow's primeval forest, murmuring benignly. Hunt's waters are dark and deep, and little can be seen beyond his fetid shores choked with vegetation.

Carol Jentsch has observed that Hunt was "attempting to follow his new goal of painting such momentary natural phenomena, yet the stillness of the scene suggests that the moment is eternal as well. The glassiness of the river, the motionless trees with neither moss nor branches swaying in the breeze, the lack of definition in the details, the bushes and leaves as clouds of green-gray color, all create a timeless image of a peaceful Florida river."[7]

As we recall, the study of painting in the South is also the study of the illustrious itinerant, and in this role Hunt served the Florida scene splendidly.

1. Peter Bermingham, *American Art in the Barbizon Mood*, (Washington, D.C.: Smithsonian Institution Press, 1975), 18
2. Carol Jentsch, in *Florida Visionaries, 1870-1930*, (Gainesville: University Presses of Florida, 1989), 30.
3. Kenneth Clark, *The Romantic Rebellion: Romantic versus Classic Art.*, (New York: Harper, 1973), 29.
4. This was the aesthetic advocated by John Ruskin in England, by Violet-le-Duc in France; and by Thomas Cole and the first generation of his followers in America.
5. E.H. Gombrich, *Art and Illusion*, (Princeton, New Jersey: Princeton University Press, 1960), 321.
6. See Helen Knowlton, *Hunt's Talks on Art*, (Boston: H.O. Houghton and Company, 1875).
7. Jentsch, 30.

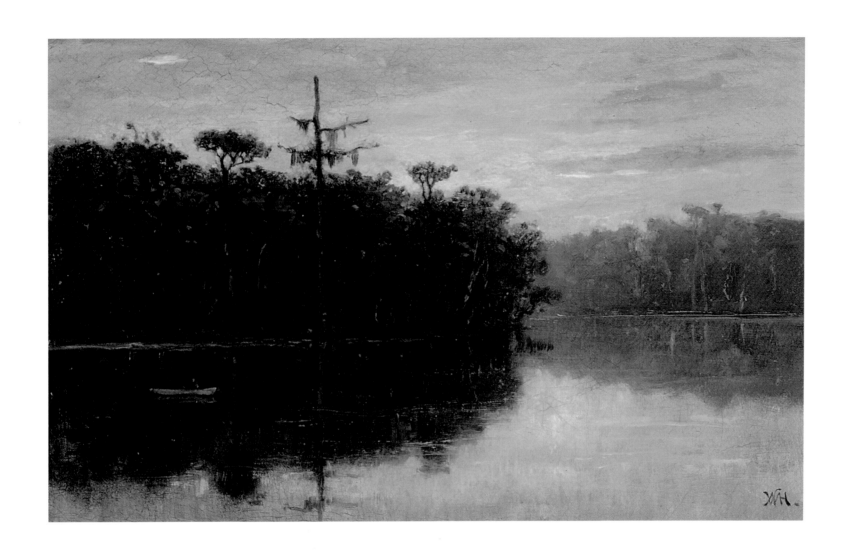

William Morris Hunt

Governor's Creek, Florida
1873-1874
Oil on canvas
10 x 16 inches
Collection of The Columbus Museum, Columbus, Georgia

George Inness
1825-1894

Born, Newburgh, New York; studied with Regis Gignoux; began to exhibit at the National Academy of Design in New York in 1844 after an apprenticeship as an engraver; worked in Paris, France, 1853-1854, and in Italy, 1870-1874; active in Tarpon Springs, Florida, 1890-1894; died Bridge-of-Allen, Scotland.

*I*nness' career spans several important stages in the development of nineteenth-century American landscape art. He began to paint with Regis Gignoux whose romantic sensibility was applied to several images of the Dismal Swamp in Virginia, thus giving the artist an early exposure to the pictorial possibilities of the Southern scene. His first works have a poised and somewhat static quality reminiscent of the seventeenth century, to which he appears to have had a lifelong devotion.

However, like Clague, he visited France and experienced the Barbizon style close range in 1853-54. Subsequently his works began to take on an increasingly mystical aura, illusionary images of the landscape in which his goal was to capture an essence of place rather than a strict truth to nature. Ultimately, "Inness began to draw...different artistic possibilities together through a synthesis into a single style, one that simultaneously acknowledged the claims of subjectivity (form and feeling) and objectivity (convincing descriptiveness)." [1]

Rosy Morning is one of his most astonishing Florida works. At first glance it clearly embodies the artist's mystic sensibility that the artist must "bring his intellect to submit to the fact that there is such a thing as undefinable—that which hides itself that we may feel after it." [2] Deep coloration and harmonic tones flood across a scene in which the sun has set upon the foreground and is receding into the rear ground with a fervent display of gold and shaded mauve.

But the painting also acknowledges a debt to the formal compositional values of seventeenth-century landscape art, especially that of Albert Cuyp, the Dutch master. While the foreground is formidable, with its looming tree thrust towards the picture plane, the rear ground is illusory, opening an awareness of the middle ground across which the solitary sailboat moves towards the right edge. The passage of this boat is not only a point of definition, opening depth and perspective, it is also a point of revery, a pensive passing across two moments of nature, one near and one far away.

1. Michael Quick, "The Late Paintings of George Inness," in Nicolai Cikovsky, Jr., *George Inness*, (Washington, D. C.: National Gallery of Art, 1985), 35.
2. Blair S. Sands, "George Inness," in *Florida Visionaries, 1870-1930*, (Gainesville: University Presses of Florida, 1989), 23.

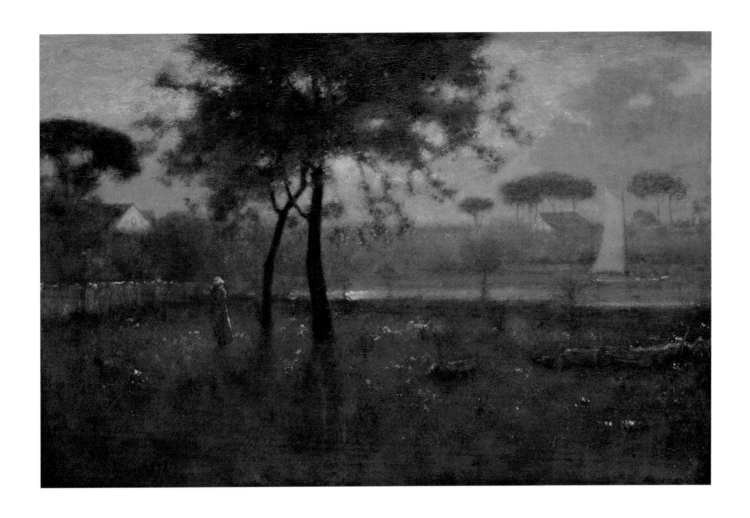

Rosy Morning
 1894
 Oil on canvas
 30 x 45 inches
 Hunter Museum of American Art, Chattanooga, Tennessee
 Gift of the Joseph H. Davenport, Jr. family in memory of Laura Voight and
 Joseph Howard Davenport

Joseph Jefferson IV
1829-1905

Born, Philadelphia; apparently self-taught, although known to have had considerable exposure to art circles in Philadelphia, New York and London; exhibited at the Pennsylvania Academy of Fine Arts, 1868; and at the National Academy of Design, New York, 1890; active in Louisiana and Palm Beach, Florida; died, Palm Beach.

Jefferson was one of the most famous actors in nineteenth century American theater, rivaling members of the Booth family in talent and surpassing them in public affection. He came from a family of actors and was best known for his role as Rip Van Winkle, a part he played repeatedly in America and abroad, notably in London during the years after the Civil War.

He always seemed to have had a great interest in art, beginning with his initial trip to Europe in 1856 to study theater. While there, at roughly the same time Clague was experiencing the Barbizon style and mood, Jefferson also came under the spell of the French painters. "I have myself found much trouble" in avoiding imitating European high style, "for now and then suggestions of Corot and Daubigny [keep] unconsciously intruding themselves from pure admiration of their work."[1]

With the wealth made from the theater and from his phenomenal seasonal tours in America after 1889, Jefferson purchased a plantation in Louisiana and later became an early resident of Palm Beach. During the winter seasons when he was not performing, he could turn his attentions to the local scene as a source for his landscape paintings, many of which were rendered in large scale and have predictably dramatic ambitions. He published an autobiography in 1890 that gives the full flavor of his aesthetic tastes in theater and art.

While Jefferson may be considered more of a gifted amateur than a highly developed painter, especially when compared to William Morris Hunt or George Inness, his works do achieve a certain power of place. He understood vanishing perspective, and from his affection for the Barbizon and Hague schools, he developed a tonal sensibility, which enhances his depictions of swamps, bayous and semi-tropical wetlands.

1. Peter Bermingham, *American Art in the Barbizon Mood.* (Washington D.C.: Smithsonian Institution Press, 1975), 152.

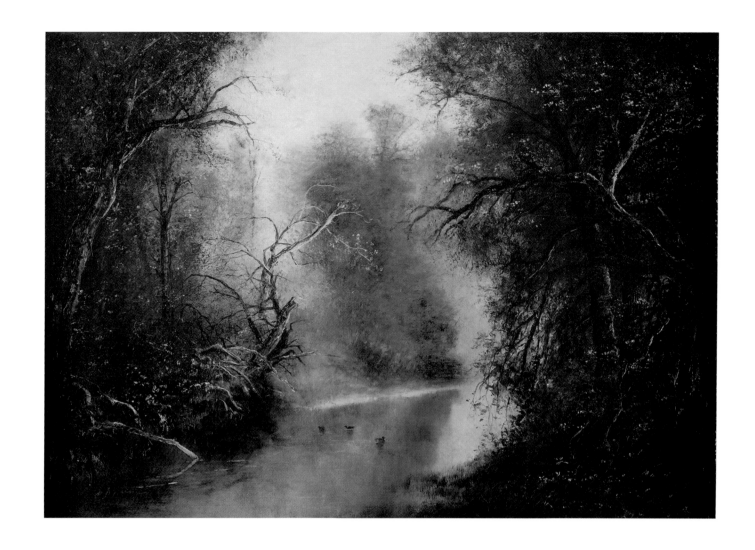

Okeefenokee
> 1886
> Oil on canvas
> 34 x 48 inches
> Courtesy of the Sam and Robbie Vickers Florida Collection

Thomas Moran
1837-1926

Born, Bolton, Lancashire, England; immigrated with his family to America in 1844, settling in Baltimore; studied with his brother, the painter Edward Moran; participated in the John Wesley Powell expedition to the Yellowstone area in 1871; active in Florida, 1877, 1879, thereafter in New York City; died, New York.

On his trip to Florida in 1877, Moran accompanied Julia S. Dodge, a feature writer for *Scribner's* magazine. This association with *Scribner's* provides an ironic association with the South that closes the circle of literary observations on the region's picturesque integrity. Moran had read, with great enthusiasm, Edward King's articles on "The Great South" and yearned to execute a series of works in Florida that would fulfill the same mission of sensitively recording a frontier scene in the midst of East Coast American prosperity.

Writing of the Fort George area for *Scribner's*, where Moran worked, Dodge summons up a full Victorian response to the scene. "And to Fort George nature has been very bountiful. About forty acres of trees grow upon its surface, our northern pines and cedars—their foliage becoming softer and finer in this southern latitude—mingling with the huge live oak, the luxuriant magnolia and the stately palm...

"Over wood and plain and sea and sky the sunset throws a glory of its own. The scene is one of perfect repose and peace. Standing here, one cannot wonder that a universal sentiment has inspired the poets of all times to find their ideal of peace and felicity in far-off islands of the sea...."[1]

1. Nancy K. Anderson, *Thomas Moran*, (New Haven, Connecticut: Yale University Press, 1997), 117

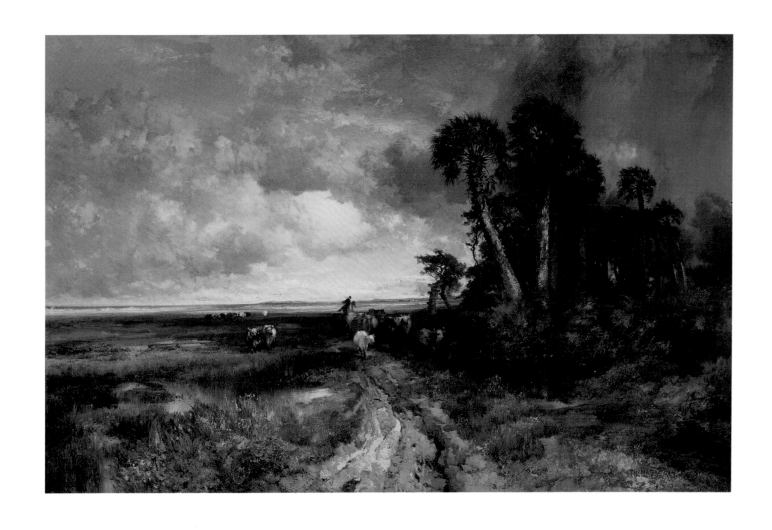

Bringing Home the Cattle, Coast of Florida
 1879
 Oil on canvas
 31½ x 49½ inches
 Albright-Knox Art Gallery, Buffalo, New York
 Sherman S. Jewett Fund, 1881
 Photo: Biff Henrich

CHECKLIST OF THE EXHIBITION

Carl Christian Brenner
1838-1888

Beechwood Trees
1885
Oil on canvas
36 x 60 inches
Cheekwood Museum of Art, Nashville, Tennessee

The Close of an Autumn Day
1885
Oil on canvas
14 x 20⅜ inches
Collection of The Speed Art Museum, Louisville, Kentucky
Bequest of Mrs. Louise J. Steenman, 1950.2.6

Winter
1885
Oil on canvas
30 x 51 inches
Collection of The Speed Art Museum, Louisville, Kentucky
Bequest of Mrs. Elizabeth M. Gray, 1958.24

William Henry Buck
1840-1888

Louisiana Pastoral: Bayou Bridge
c. 1880
Oil on canvas
26 x 40 inches
The Ogden Collection, New Orleans, Louisiana

Richard Clague
1821-1873

Back of Algiers
c. 1870-1873
Oil on canvas
13¾ x 20 inches
New Orleans Museum of Art
Gift of Mrs. Benjamin M. Harrod

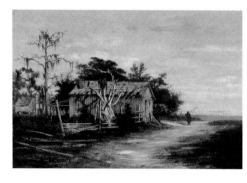

The Shore of Lake Pontchartrain,
Mandeville
c. 1865
Oil on canvas
12 x 18 inches
Morris Museum of Art, Augusta, Georgia
1995.008

George Edward Cook
c. 1860-1930

Untitled Landscape
1892
Oil on canvas
27 x 47 inches
Morris Museum of Art, Augusta, Georgia
1996.022

George David Coulon
1822-1904

Bayou Beauregard, St. Bernard Parish
1887
Oil on canvas
24 x 33 inches
The Ogden Collection, New Orleans, Louisiana

Elliott Daingerfield
1859-1932

Carolina Sunlight
c. 1915
Oil on canvas
24 x 28¼ inches
Morris Museum of Art, Augusta, Georgia
1989.01.045

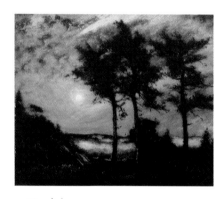

Moonlight
1925
Oil on canvas
30 x 36 inches
Mint Museum of Art, Charlotte, North Carolina
Gift of the Mint Museum Auxiliary, 1971.18

Sunset Glory
c. 1915
Oil on canvas
27½ x 33⅜ inches
Morris Museum of Art, Augusta, Georgia
1990.014

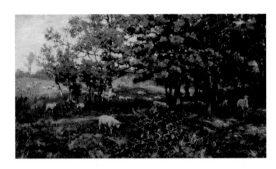

Gaines Ruger Donoho
1858-1916

Sheep, Late Afternoon
1891
Oil on canvas
24 x 44 inches
Greenville County Museum of Art, Greenville, South Carolina

William C. A. Frerichs
1829-1905

After the Storm
c. 1870
Oil on canvas
26 x 44 inches
Courtesy of Mr. and Mrs. William S. Morris III

Herman Herzog
1832-1932

Florida Marsh
1888-1910
Oil on canvas
15⅞ x 20½ inches
Morris Museum of Art, Augusta, Georgia
1989.01.077

Forest with Heron
undated
Oil on canvas
39 x 32 inches
Lent by Dr. and Mrs. David A. Cofrin
Courtesy of the Harn Museum of Art, University of Florida, Gainesville, Florida

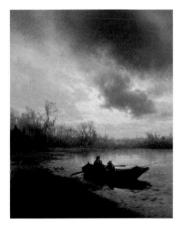

On Alachua Lake (Girls in a Rowboat)
undated
Oil on canvas
39 x 32 inches
Lent by Dr. and Mrs. David A. Cofrin
Courtesy of the Harn Museum of Art, University of Florida, Gainesville, Florida

William Morris Hunt
1824-1879

Governor's Creek, Florida
1873-1874
Oil on canvas
10 x 16 inches
Collection of The Columbus Museum, Columbus, Georgia

Sunrise, Florida
c. 1874
Oil on canvas
10 x 16 inches
Courtesy of the Sam and Robbie Vickers Florida Collection

George Inness
1825-1894

Rosy Morning
1894
Oil on canvas
30 x 45 inches
Hunter Museum of American Art, Chattanooga, Tennessee
Gift of the Joseph H. Davenport, Jr. family in memory of Laura Voight and Joseph Howard Davenport

Joseph Jefferson IV
1829-1905

Okeefenokee
1886
Oil on canvas
34 x 48 inches
Courtesy of the Sam and Robbie Vickers Florida Collection

Harvey Joiner
1852-1932

Fall
undated
Oil on canvas
9¼ x 19⅝ inches
Courtesy of Isabel McHenry Clay

Spring
undated
Oil on canvas
9½ x 19¼ inches
Courtesy of Isabel McHenry Clay

Wooded Landscape
c. 1900
Oil on canvas
28 x 40 inches
Morris Museum of Art, Augusta, Georgia
1989.08.287

George Herbert McCord
1849-1909

Sunset on St. Johns River
1878
Oil on canvas
34 x 26 inches
The Ogden Collection, New Orleans, Louisiana

Joseph Rusling Meeker
1827-1889

The Acadians in the Achafalaya, "Evangeline"
1871
Oil on canvas
32⅛ x 42⅚ inches
Brooklyn Museum of Art, Brooklyn, New York
A. Augustus Healy Fund, 50.118

Louisiana Bayou
c. 1885
Oil on canvas
20⅛ x 36⅛ inches
Collection of the Montgomery Museum of Fine Arts,
Montgomery, Alabama
Montgomery Museum of Fine Arts Association Purchase

Solitary Pirogue by the Bayou
1886
Oil on canvas
17¾ x 30 inches
Morris Museum of Art, Augusta, Georgia
1993.004

Andres Molinary
1847-1915

Landscape with Live Oak
undated
Oil on canvas
16⅞ x 26½ inches
Morris Museum of Art, Augusta, Georgia
1989.06.272

Thomas Moran
1837-1926

Bringing Home the Cattle,
Coast of Florida
1879
Oil on canvas
31½ x 49½ inches
Albright-Knox Art Gallery, Buffalo, New York
Sherman S. Jewett Fund, 1881

Marshall Joseph Smith, Jr.
1854-1923

Bayou Plantation
c. 1879-1900
Oil on canvas
17 x 36¼ inches
New Orleans Museum of Art
Gift of William E. Groves

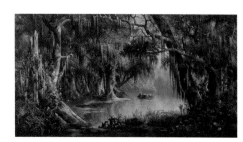

Meyer Straus
1831-1905

Bayou Teche
c. 1870
Oil on canvas
30 x 60 inches
Morris Museum of Art, Augusta, Georgia
1989.03.239

James Everett Stuart
1852-1941

Kentucky Harvest
1909
Oil on canvas
24 x 42 inches
Merrill Gross Family Collection

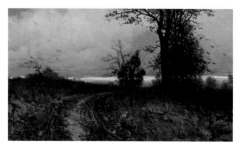

Henry Ossawa Tanner
1859-1937

Georgia Landscape
1889-1890
Oil on canvas
17¾ x 32¼ inches
Morris Museum of Art, Augusta, Georgia
1989.01.201

John Martin Tracy
1843-1893

A Shepherdess
undated
Oil on canvas
30 x 50 inches
Morris Museum of Art, Augusta, Georgia
Gift of Morris Communications Corporation
1995.024

Allen, James Lane. *The Blue-Grass Region of Kentucky and Other Articles.* New York: Macmillan Company, 1900.

Anderson, Nancy K. *Thomas Moran.* Washington, D.C.: National Gallery of Art; New Haven: Yale University Press, 1997.

Beesch, Ruth K. *Florida Visionaries, 1870-1930.* Gainesville: University Presses of Florida, 1989.

Bermingham, Peter. *American Art in the Barbizon Mood.* Washington, D.C.: Published for the National Collection of Fine Arts by the Smithsonian Institution Press, 1975.

Bier, Justus. "Carl C. Brenner: A German American Landscapist," *The American-German Review,* April 1951.

Cabell, Branch, and A. J. Hanna. *The St. Johns, a Parade of Diversities.* New York: Farrar & Rinehart, Inc., 1943.

Campbell, Olive D. *The Southern Highlands.* New York: The Russell Sage Foundation Library, 1920.

Chambers, Bruce W. *Art and Artists of the South: The Robert P. Coggins Collection.* Columbia: University of South Carolina Press, 1984.

Cikovsky, Nicolai Jr. *George Inness.* Washington, D. C.: National Gallery of Art, Department of Extension Programs, 1987.

Cikovsky, Nicolai Jr. and Michael Quick. *George Inness.* Los Angeles County Museum of Art; New York: Harper & Row, 1985.

Clark, Kenneth. *Landscape into Art.* London: Penguin, 1956.

————. *The Romantic Rebellion: Romantic versus Classic Art.* New York: Harper, 1973.

Hall, B. C., and C. T. Wood. *The South.* New York: Scribner, 1995.

King, Edward. *The Great South: A Record of Journeys in Louisiana.* Hartford, Connecticut: American Publishing Company, 1875.

Knoepflmacher, U. C., and G. B. Tennyson, eds. *Nature and the Victorian Imagination.* Berkeley: University of California Press, 1977.

Larkin, Oliver. *Art and Life in America.* New York: Rinehart & Company, 1949.

Leeuw, Ronald de, John Sillevis, and Charles Dumas, eds. *The Hague School: Dutch Masters of the 19th Century.* London: Royal Academy of Arts, published in association with Weidenfeld and Nicolson, 1983.

Mahe, John A. II, and Rosanne McCaffrey, eds. *Encyclopaedia of New Orleans Artists, 1718-1918.* New Orleans, Louisiana: The Historic New Orleans Collection, 1987.

Meeker, Joseph Rusling. "Some Accounts of Old and New Masters," *The Western,* 1878.

North Carolina Museum of Art. *William C. A. Frerichs, 1829-1905.* Raleigh: North Carolina Museum of Art, 1974.

Rinhart, Floyd, and Marion Rinhart. *Victorian Florida: America's Last Frontier.* Atlanta, Georgia: Peachtree Publishers Limited, 1986.

Taylor, Joshua. *America as Art.* Washington, D. C.: Published for the National Collection of Fine Arts by the Smithsonian Institution Press, 1976.

Toledano, Roulhac. *Richard Clague, 1821-1873.* New Orleans, Louisiana: New Orleans Museum of Art, 1974.

Ward, William S. *A Literary History of Kentucky.* Knoxville: University of Tennessee Press, 1988.

Wilmerding, John, ed. *American Light: The Luminist Movement, 1850-1875: Paintings, Drawings, Photographs.* Lawrenceville, New Jersey: Princeton University Press; Washington, D.C.: National Gallery of Art, 1989.

Archival Sources
Center for the Study of Southern Painting, Morris Museum of Art, Augusta, Georgia.
The Filson Club, Louisville, Kentucky.
National Museum of American Art and National Portrait Gallery Library, Smithsonian Institution, Washington, D.C.

INDEX OF ILLUSTRATIONS

Brenner, Carl Christian 29, 30, 31

Buck, William Henry. 15

Clague, Richard. 17, 52

Cook, George Edward. 10

Coulon, George David . 19

Daingerfield, Elliott . 27, 52

Donoho, Gaines Ruger . 53

Frerichs, William C.A.. 24

Herzog, Herman. 41, 53

Hunt, William Morris . 43, 45

Inness, George . 47

Jefferson, Joseph IV. 49

Joiner, Harvey. 33, 34, 35

McCord, George Herbert. 39

Meeker, Joseph Rusling 4, 12, 21

Moran, Thomas. 36, 51

Smith, Marshall Joseph, Jr.. 23

Straus, Meyer . 54

Stuart, James Everett . 6

Tanner, Henry Ossawa . 54

Tracy, John Martin . 11

ACKNOWLEDGEMENTS

I should like to express my thanks to the Art Historical Institute at the University of Amsterdam for access to books, computer services and a desk. Sincere regards for digging through the J.B. Speed Art Museum storeroom go to Charles Pittenger and Lisa Parrott Rolfe. All the lenders have been most kind, but special thanks go to the Ogden Collection, the New Orleans Museum of Art and Mrs. Norton Clay, who let me raid her guest room for the two Joiners. At the Morris Museum of Art, Catherine Wahl is always so wonderfully helpful.

— ECP

About the Author

*E*still Curtis Pennington holds the title of Morris Curator of Southern Painting for the Morris Museum of Art, and is the author of numerous exhibition catalogs, books and articles in the field of Southern art. He received a B.A. degree in American History and Literature from the University of Kentucky, and did further study in English literature at the University of Georgia. He also studied American Culture and Art History in the Smithsonian Institution Ph.D. program at George Washington University. Prior to becoming associated with the Morris Museum of Art in 1989, Mr. Pennington served on the staffs of the National Portrait Gallery and the Archives of American Art at the Smithsonian. He also has served as the Director of the Lauren Rogers Museum of Art in Laurel, Mississippi, Curator of the Ogden Collection in New Orleans, and Curator of Painting at the New Orleans Museum of Art.

His publications include *William Edward West, Kentucky Painter; The Last Meeting's Lost Cause; Look Away: Reality and Sentiment in Southern Art*, and *Downriver: Currents of Style in Louisiana Painting 1800-1950*. For the Morris Museum of Art, he has written *A Southern Collection; Gracious Plenty: American Still Life Paintings in Southern Collections; Light of Touch: Works on Paper in the Permanent Collection; Will Henry Stevens: An Eye Transformed, a Hand Transforming; Passage and Progress in the Works of William Tylee Ranney; Frontier Sublime: Alaskan Art from the Juneau Empire Collection*; and *Heirs of Magic Realism: Representation in Current Dutch Art*, among others. He has lectured extensively on Southern painting, decorative arts and culture. Much of his time is divided between his homes in Kentucky and Amsterdam. He was elected a Fellow of the Royal Society for the encouragement of Arts, Manufactures and Commerce (RSA) in 1998.

MUSEUM STAFF

Louise Keith Claussen	Director
Elizabeth Davis Jones	Development Officer
Patricia Moore Shaffer	Curator of Education
Janann Reynolds	Education Services Coordinator
Dorothy Eckmann	National Faculty Program Officer
Catherine Wade Wahl	Registrar
Kelly Woolbright	Assistant Registrar
Melinda Marks Murphy	Store Manager
Eben Jones	Finance Officer
Cary Wilkins	Librarian and Archivist
Leslie Mitchener	Marketing and Public Relations Coordinator
James Patrick Tar	Senior Preparator
Robert Bazemore	Preparator
Lottie Gilchrist	Office Manager
Rex Bell	Security Chief
Don Frye	Security Guard
Ricky Lamb	Security Guard
Dile Bennett	Security Guard
Nita Mohanty	Store Assistant
John Loebl	Store Assistant
Brenda Hall	Sunday Reception Desk
Estill Curtis Pennington	Morris Curator of Southern Painting

Design: Tina Burch
Color Separations: Mark Albertin, Diann Giles
 Morris Communications Corporation
Printing: State Printing

Morris Museum of Art
One 10th Street • Augusta, Georgia 30901 • (706) 724-7501
www.themorris.org